MIDDLESEX COUNTY
THROUGH TIME

ROBERT GILINSKY

AMERICA
THROUGH TIME®
ADDING COLOR TO AMERICAN HISTORY

For my family

With love

America Through Time is an imprint of Fonthill Media LLC
www.through-time.com
office@through-time.com

Published by Arcadia Publishing by arrangement with Fonthill Media LLC
For all general information, please contact Arcadia Publishing:
Telephone: 843-853-2070
Fax: 843-853-0044
E-mail: sales@arcadiapublishing.com
For customer service and orders:
Toll-Free 1-888-313-2665

www.arcadiapublishing.com

First published 2019

ISBN 978-1-63500-081-8

Typeset in Mrs Eaves XL Serif Narrow
Printed and bound in England

INTRODUCTION

Middlesex County may be the heart of Central Jersey, but there is a distinct North Jersey/
South Jersey divide therein with the Raritan River setting the approximate boundary. All
points north of the Raritan exude North Jersey attitude. With the industrial population
density and the infamously congested I-287 corridor spewing traffic in and out of the
Garden State Parkway, the New Jersey Turnpike, Route 1, Route 9, and Route 18 to name
only a few, the landscape and people possess a distinct urban flair. Many points south of
the Raritan River in the county boast small-time rural South Jersey charm. Dotted with
farms and suburbia, there is a more calm, easy-going nature in both the atmosphere
and populous. As farmlands and factories are giving way to developments and shopping
malls, one can feel an uncomfortable homogenization settling in, which has been the
norm throughout the western world.

One of the four original counties of the 1675 partition of the province of East Jersey, the
region was officially incorporated in 1683. In 1688, Somerset County was organized and
split off. In 1693, Middlesex County was divided into three townships: Piscataway, Perth
Amboy, and Woodbridge. The twenty-five independent municipalities which currently
make up the county can all be traced back to one of these three parent townships.
Although much history has met with wrecking ball and fire, there are still more than a
few hidden gems. One admirable note about the area's growth was that when the county
underwent its most extensive advances in the mid-twentieth century, they established
East Jersey Old Town Village Park and worked with landowners to relocate historic
structures to the park when threatened by the roar of progress.

Many of Thomas Edison's greatest inventions, including the light bulb and phonograph,
were conceived at his humble workshop in Menlo Park. Middlesex County can also
count many other firsts as have happened within her borders. Woodbridge was the site
of the first printing press in New Jersey in 1751. The very first college football game was
played at Rutgers in 1869 when the Scarlet Knights defeated Princeton 6 to 4. The first
black man to vote in the United States did so in Perth Amboy in 1870 (the gentleman
was the namesake and long-time custodian at the institution pictured on page 64). The
first airmail flight made by the US Postal Service took off from a small airfield in South
Amboy in 1912. Middlesex County was the site of the first Vo-Tech school system and
also the first county college in New Jersey. Band-Aids, baby powder, and duct tape were

among the innovations developed by Johnson & Johnson in New Brunswick. Selman Waksman's team at Rutgers won the Nobel Prize for one of their many breakthroughs in antibiotics during and after the second World War.

Middlesex County has definitely left its mark on our venerated pop culture. Legendary actor Kirk Douglas has joked about his formative days riding the Central Jersey train back from auditions in New York City to a mansion in Highland Park. His young wife's sister had married the heir to the Johnson & Johnson fortune and the newlywed Douglases were staying at his sprawling estate. Their son Michael was born at St Peter's Hospital in New Brunswick. Susan Sarandon and Brittany Murphy both grew up in Edison. Every member of the original, classic lineup of *Bon Jovi* grew up in Middlesex County: Jon Bon Jovi, Sayreville; Richie Sambora, Woodbridge; Tico Torres, the Colonia section of Woodbridge; David Bryan, Edison; and Alec John Such, Perth Amboy. Angst-ridden Steely Dan frontman Donald Fagen pent up loads of adolescent frustration during his unhappy high school years living in the Kendall Park section of South Brunswick. One of the greatest magicians of all time, David Copperfield performed his first parlor trick for his family in the den of his Metuchen childhood home. Quite a few classic 80's television stars hail from Middlesex County as well: *Welcome Back Kotter* star Robert Hegyes grew up in Metuchen and was still living there sixty years later when he died from a heart attack; Greg Evigan from *BJ & The Bear* and *My Two Dads* (Sayreville); Kelsey Grammer from *Cheers* (Colonia); Mel Harris from *thirtysomething* (North Brunswick); troubled actor Robert Pastorelli from *Murphy Brown* (Edison); and Danny Pintauro from *Who's the Boss?* (Milltown). Journalist and *New York Times* columnist Anna Quindlen was raised in South Brunswick. Children's author Paula Danziger spent her adolescence in Metuchen. Sixties supermodel Suzy Parker grew up in Highland Park. NFL stars Alex Wojciechowicz, Joe Theismann, and Drew Pearson all grew up in and played high school football for South River. Renowned artist and sculptor George Segal settled down after getting married and lived on a small chicken farm he bought in South Brunswick where he worked and lived for most of life.

I was recently discussing the prehistoric fossil record of different localities in New Jersey with a friend. We were discussing the 40-foot crocodiles terrorizing the swampy area which is now Sayreville and Old Bridge some 100 million years ago. We talked about the earliest known fossil of a bird feather which was discovered in amber deposits, also in Sayreville. It seems as if Middlesex County has led the pack since the pack slithered its way out of the sea so many millennia ago.

<div align="right">

Robert Gilinsky
Spring 2018

</div>

ON THE COVER

Front: The New Brunswick shoreline on the Raritan River as viewed from Highland Park in 1913 and 2018.
Back: The landmark Scheuer building at the Five Corners in Perth Amboy as viewed in 1900, 1905, 1915, and 2018.

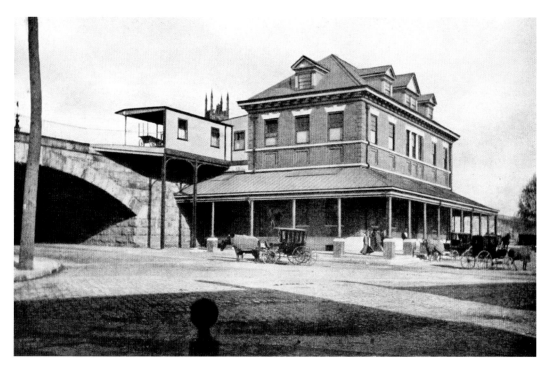

NEW BRUNSWICK TRAIN STATION: New Brunswick was among the earliest rail station locations in New Jersey, having hosted a stop since 1838. The current installation was built in 1903, and is pictured shortly thereafter. Although the physical appearance of the station remains basically the same, the building has been modernized and revamped several times over the past century, and was in the final stages of a renovation in the modern photo presented here.

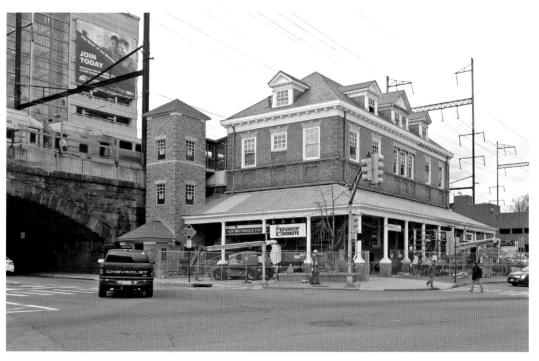

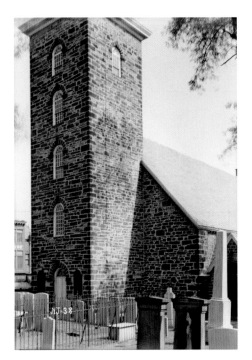 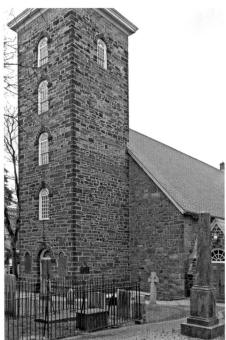

CHRIST CHURCH (TOP) AND FIRST REFORMED CHURCH (BOTTOM): Presented here are photo comparisons of two of New Brunswick's most historic houses of worship. The organization of the Episcopal Christ Church has early eighteenth century origins, and the church building (pictured in 1937) itself dates to 1742. The Dutch Reformed congregation was organized in 1717, and the current building, shown in a *c.* 1910 postcard, was completed in 1812.

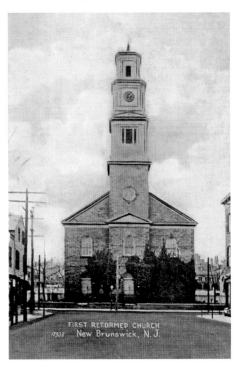 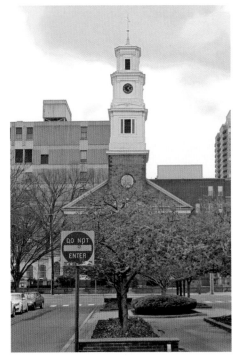

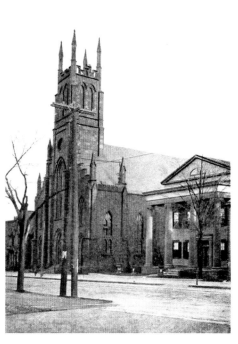

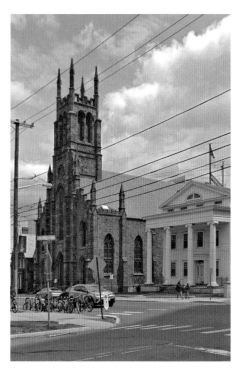

ST. PETER'S CATHOLIC CHURCH (TOP) AND LIVINGSTON AVENUE BAPTIST CHURCH (BOTTOM): Two more of New Brunswick's most well-known churches are pictured in 1905. St. Peter's congregation was organized in the 1830s. The massive complex was constructed from 1854-65. The Livingston Avenue church began as an offshoot of the George Street Baptist Church, and after outgrowing several earlier buildings, the congregation settled into the present Romanesque structure, completed in 1893.

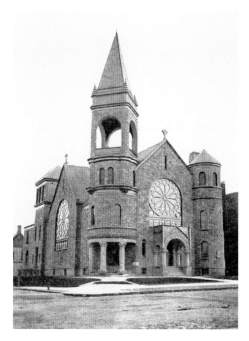

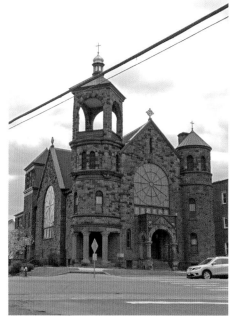

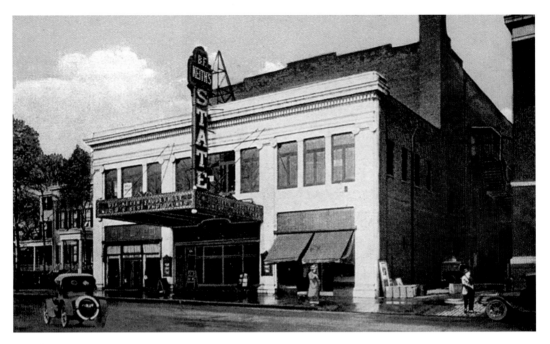

THE STATE THEATRE: Built in the heart of New Brunswick by theatre maverick Walter Reade in 1921, State Theatre hosted both vaudeville and motion picture presentations. The postcard view here dates from the 1920s, shortly after the theatre opened. It was one of the first area cinemas outfitted for the presentation of sound motion pictures in 1929, and was one of the first area venues to host rock concerts in the mid-1950s.

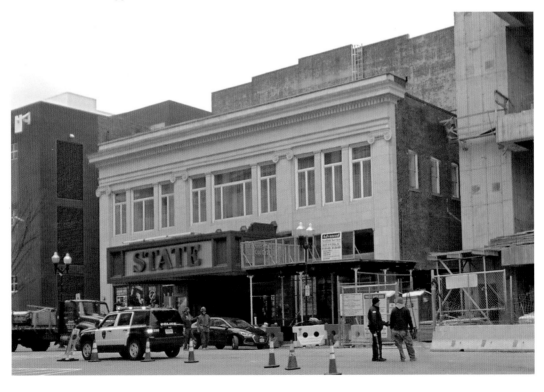

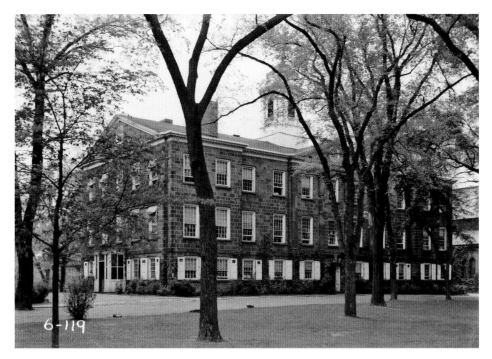

OLD QUEENS, RUTGERS UNIVERSITY: Founded as Queens College in 1766, Rutgers University's oldest extant and most revered building was constructed from 1809-25. Originally housing most of the college's facilities, the building was designed by John McComb Jr., who designed many area landmarks including City Hall and Gracie Mansion in New York City. The institution struggled to complete the building due to lack of funds. Revolutionary war hero, Col. Henry Rutgers, donated $5,000 to aid in the completion. As a sign of gratitude, the college took his name.

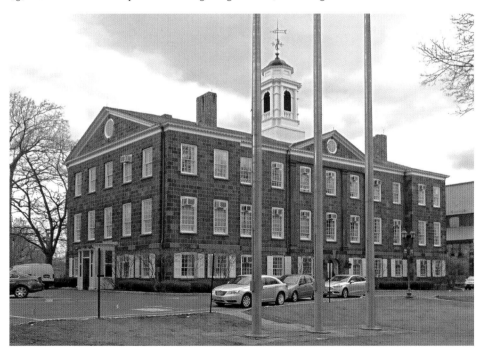

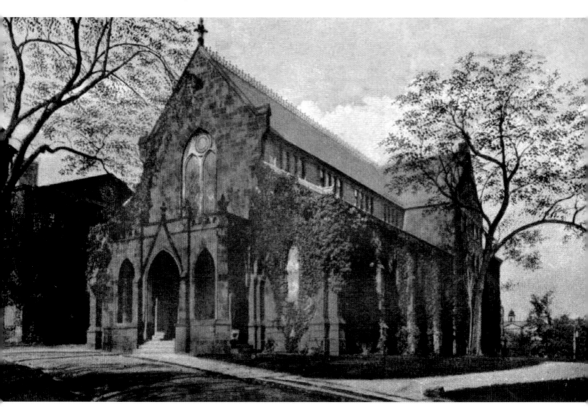

KIRKPATRICK CHAPEL: The Rutgers landmark was built in 1873 through the courtesy of a generous gift from the estate of Sophia Kirkpatrick, the widow of a wealthy politician and Rutgers trustee. Originally utilized by the students for daily worship, the chapel also housed the school library. The building (as seen here in the late 1920s) currently serves as a meeting place for special events, lectures, and university presentations.

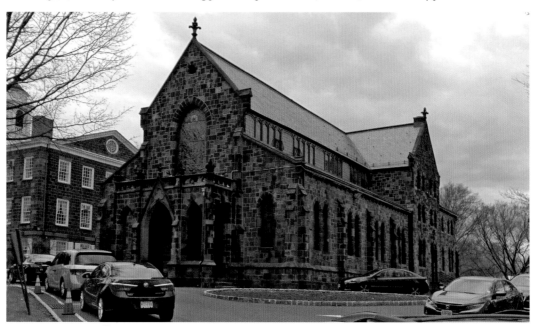

THE DANIEL SCHANCK OBSERVATORY: Daniel Schanck, a successful businessman, donated a sizable sum to Rutgers to construct the observatory, which was completed in 1865. The structure ceased to be used as an observatory in 1979. Years of neglect and vandalism took its toll on the building which was restored in 2012. Pictured in 1960, the observatory is located in the Queens Campus main parking lot, which was the far corner of campus when it was built. It is currently used by the elite Cap and Scull Society.

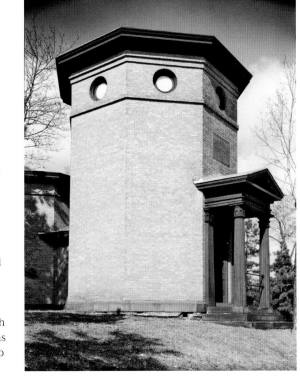

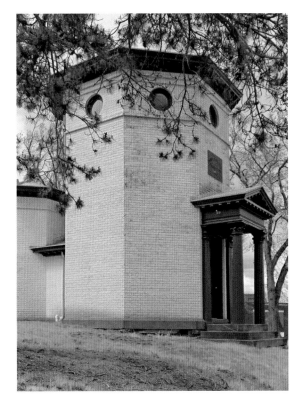

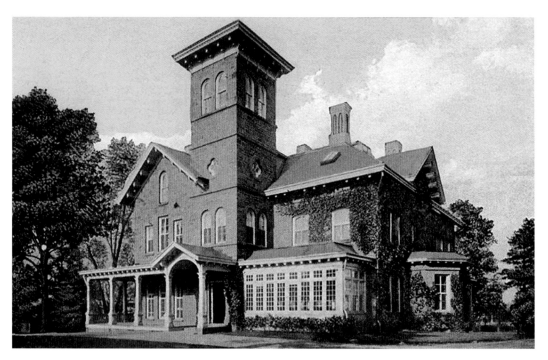

THE LEVI JARRARD HOUSE: Corrupt politician Levi Jarrard built this mansion in 1868 using stolen money. Jarrard held many different positions within Middlesex County including Collector and Postmaster. In 1883, suspicions arose of his embezzlements, and he was eventually convicted and died in prison. In 1918, when the New Jersey College for Women (now Douglass College, part of Rutgers) was founded, this building (seen in the 1920s) was utilized as the main hall.

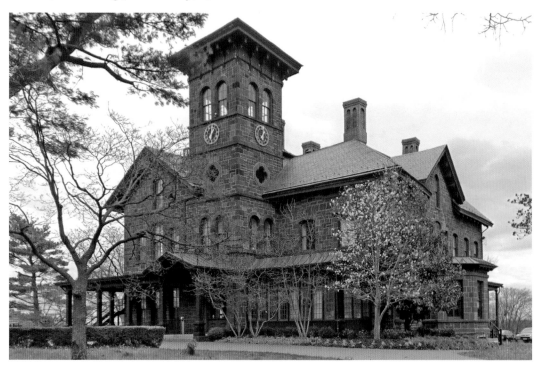

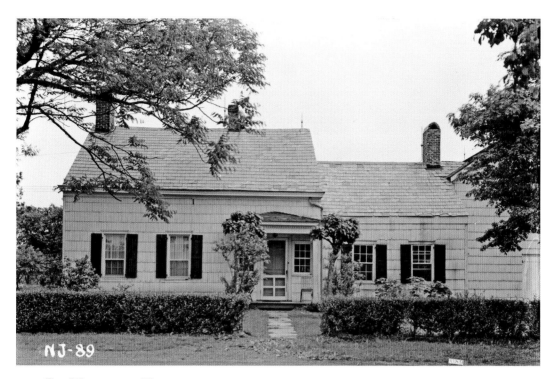

THE WILLIAMSON HOUSE: Constructed *c.* 1765 by William Williamson in the Franklin Park section of what is now North Brunswick, the house remained in the Williamson Family for nearly a century and a half. Originally a farm off of Cozzens Lane, the Fairland Management Corporation purchased the tract in 1936 and turned it into a memorial park cemetery. The administrative offices for Franklin Memorial Park have been housed in the Williamson House (1938 picture) since its inception.

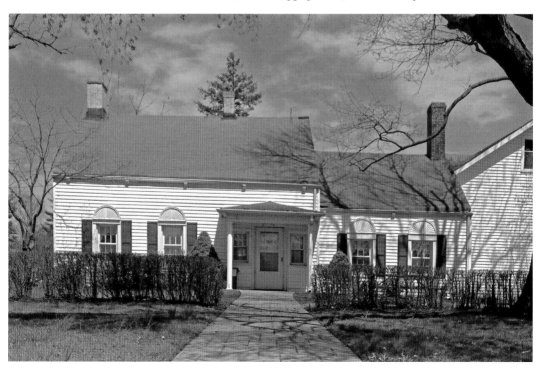

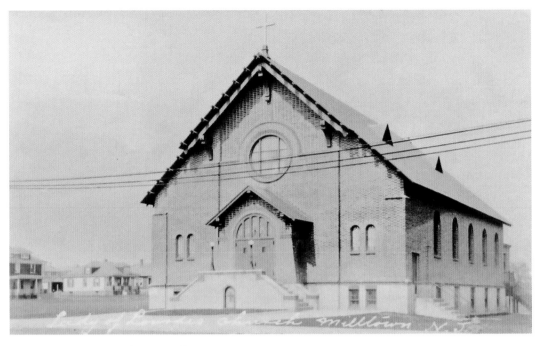

OUR LADY OF LOURDES CATHOLIC CHURCH: Pictured shortly after the Milltown building's construction on North Main Street in the 1910s, the church opened a school at the Cleveland Avenue convent during the early 1940s. Dwindling enrollment forced the school's closure in 2013. Other than a more accessible stairway, the exterior of the parish has changed little over the past century

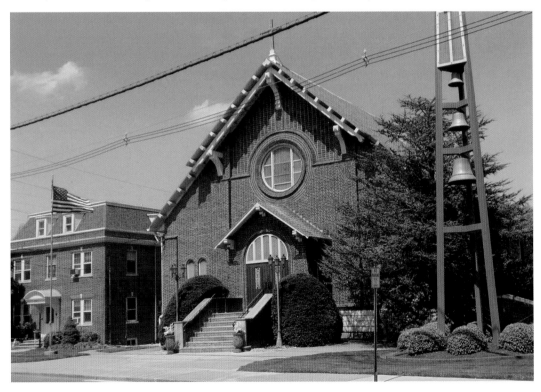

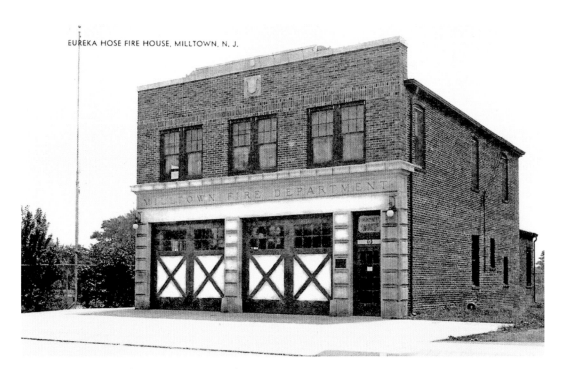

EUREKA HOSE COMPANY, NUMBER ONE: This is the secondary Milltown firehouse, built in the 1920s on Cottage Avenue, pictured on a 1940s postcard. The firehouse was constructed to supplement the 1889 station house located on South Main Street. In May of 2018, Milltown broke ground on a new borough complex, leaving the fate of this firehouse as uncertain. The new complex will include a modern fire headquarters with an ample garage which will likely render both existing houses obsolete.

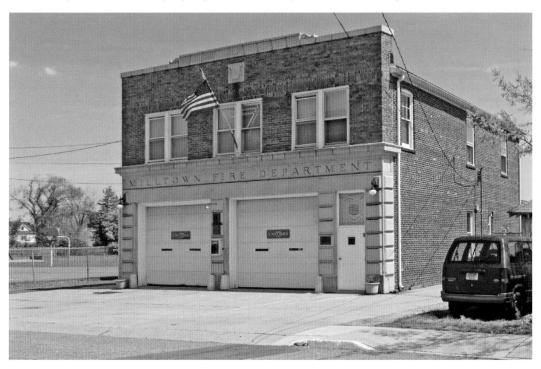

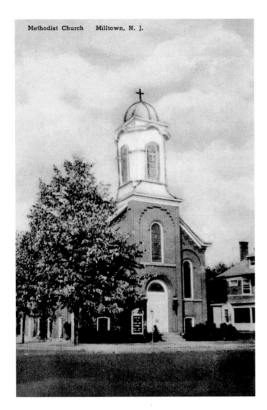

Methodist Church Milltown, N. J.

MILLTOWN FIRST METHODIST CHURCH:
The church was built on North Main Street in
1872, replacing an earlier building from 1851.
The congregation grew out of the New Brunswick
parish, from which they severed ties with in
1854. The baby boom in the late 1940s and 1950s
led to several additions to accommodate the
Sunday school. In 1963, overcrowding led to the
founding of the Aldersgate Methodist Church,
located in East Brunswick.

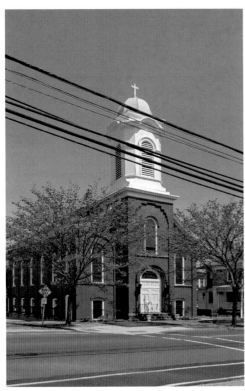

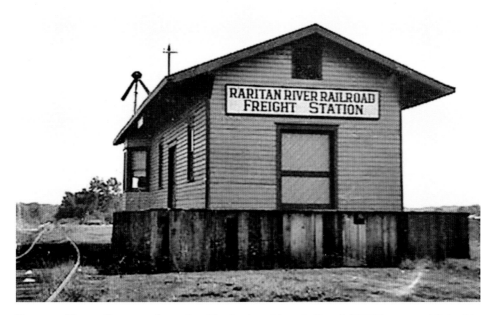

RARITAN RIVER FREIGHT STATION: The Raritan River Railroad (RRRR) was established in 1888 and ran from South Amboy to New Brunswick, with Milltown as the penultimate stop. The station was erected in the early 1900s and was a busy point of commerce when the Michelin Tire Company took over the A&V Rubber Works on Main Street in 1907. In the late 1950s, passenger and freight stops at Milltown became a thing of the past. The RRRR was absorbed into Conrail in 1980, and the line is seldom used. The last remaining RRRR station in existence, this structure has been earmarked for preservation and removal to a different location by the local chapter of the National Railway Historical Society.

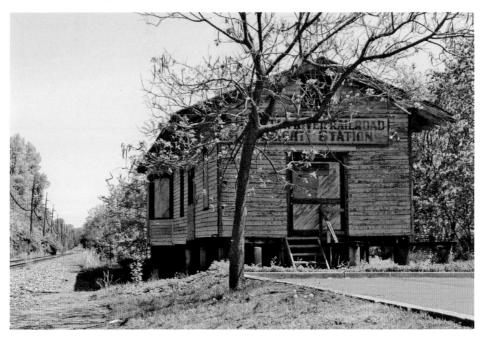

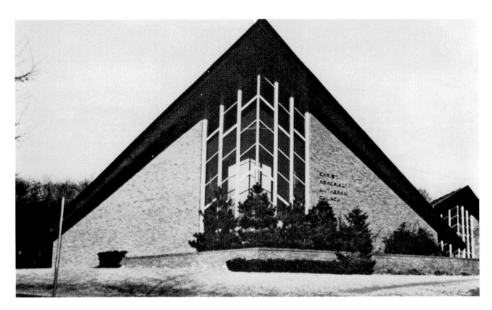

SHRUBBERY GONE WILD!: This image comparison of the Christ Memorial Lutheran Church in East Brunswick spans roughly forty years, with the vintage image dating from the mid-1970s, a few years after the congregation (which was founded in 1956) built the church. The image is included as an extreme illustration of the woes of any author who intends on attempting to assemble a local repeat photography volume. Trees, chopped by the scores for fuel and shelter since the invention of photography, are on the rise. Literally.

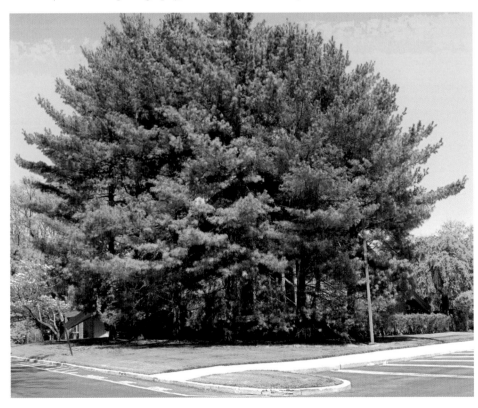

ST. THOMAS ROMAN CATHOLIC
CHURCH: The church was constructed
in 1921 in East Brunswick on Old
Bridge Turnpike. In 1957, the parish
purchased land along Route 18 in what
is now Old Bridge in order to construct
a new church and school, which
was completed in 1959. The church
building was sold to the Nativity of Our
Lord Byzantine Catholic congregation,
who continue to worship there.

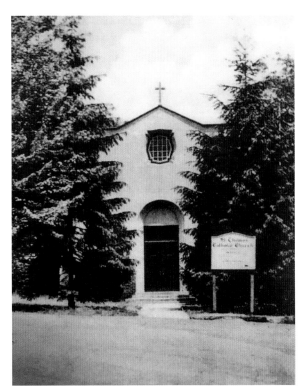

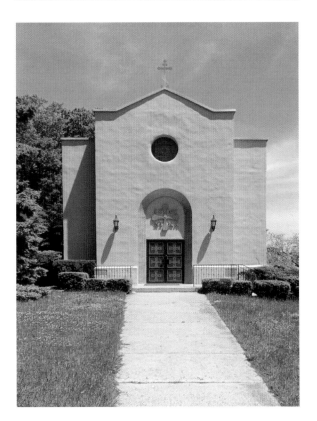

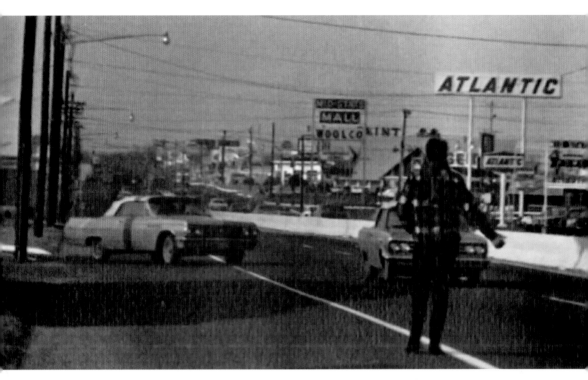

HITCHIN' A RIDE: A young hitch-hiker stands on the edge of Route 18 in East Brunswick the early 1970s. Although practically unheard of in 2018, the practice was the preferred mode of transportation for teenagers without wheels in past generations, practically since the advent of the automobile. Upon opening in August of 1958, the Mid-State Mall (visible at right) has been a primary shopping destination for area residents. Woolco is one of the anchor stores in the 1970s view.

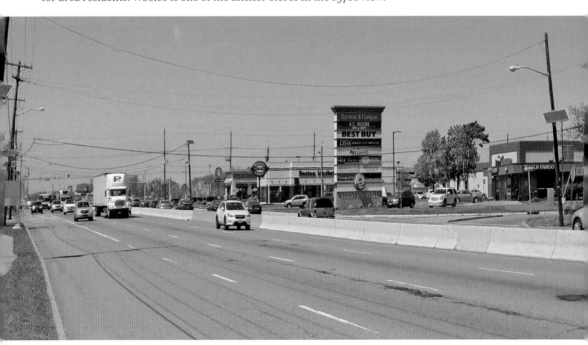

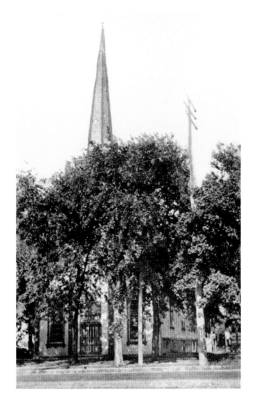

THE FIRST PRESBYTERIAN CHURCH AT DAYTON: The venerable landmark in the Dayton section of South Brunswick was constructed in 1870. There were many issues with the construction, especially in the interior which were addressed with a considerable overhaul in 1911-2. As evidenced by the photo comparison from the 1910s, the church has always been very elusive to photographers due to the numerous trees surrounding it. Published at a time when contrast-lacking photos were retouched with grease pencils, it seems there was an uneven proof surface behind the crooked-looking spire.

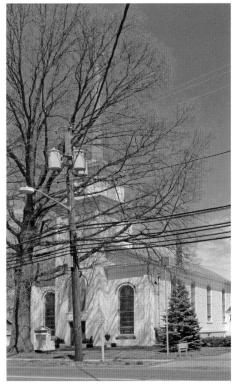

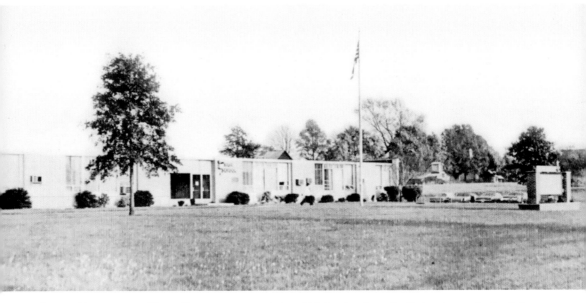

SOUTH BRUNSWICK HIGH SCHOOL: A consolidated high school was built for the students of the numerous different communities which make up South Brunswick in 1960. As the township continued to grow over the next few decades, the building was enlarged several times. Pictured in the 1970s, the school was replaced by a much larger facility in 1997. This building currently houses the Crossroads South Middle School.

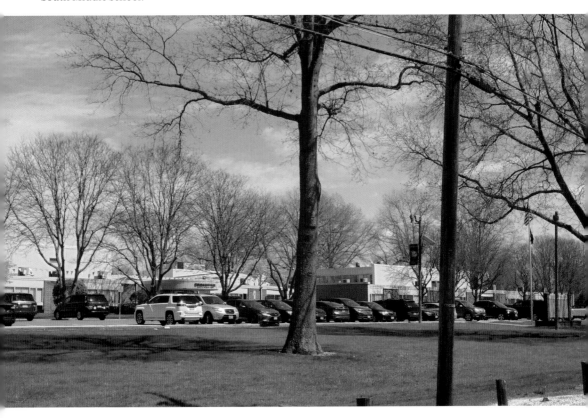

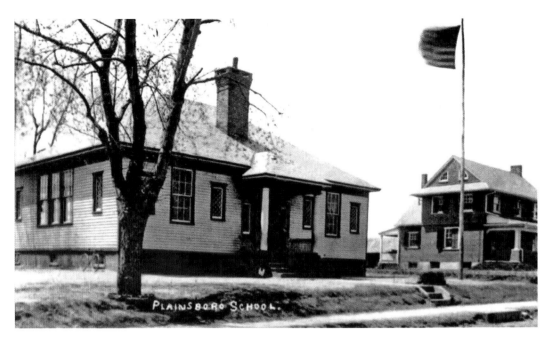

PLAINSBORO SCHOOL: This two-room schoolhouse replaced a rudimentary one-room facility at the same location in 1908 (about the time of this postcard view). This building was in turn also outgrown within a generation, and a larger, four-room edifice was constructed behind it in 1924. In an unusual move, Plainsboro schools merged with the neighboring West Windsor district in 1969, despite the fact that the adjoining towns are in different counties. The two-room schoolhouse now houses the area special services division for the district.

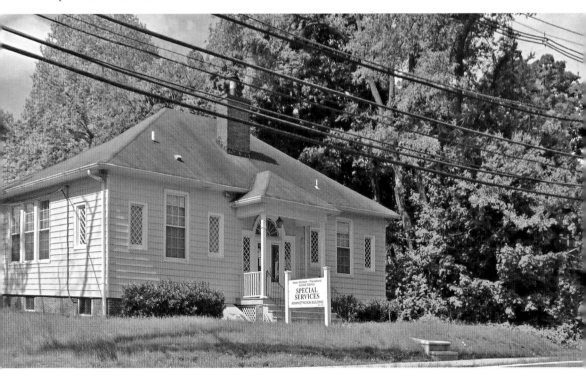

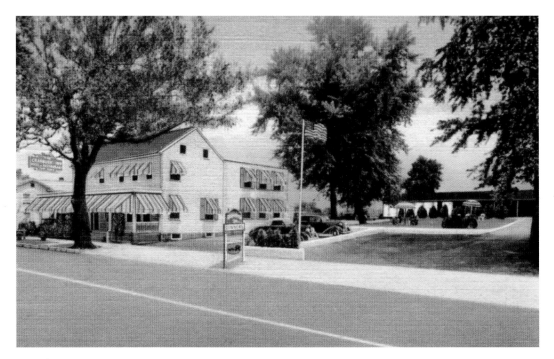

THE CRANBURY INN: Richard Handley constructed a posthouse and a tavern in the mid-eighteenth century on South Main Street in Cranbury. Peter Perrine subsequently purchased the property in 1800, and built the inn-house fronting Main Street which connected the two buildings. The property changed hands quite a few times, and was known as the United States Hotel for most of the nineteenth century. The current moniker was devised in 1920 by then-owner J. T. Wincklhofer, the local Justice of the Peace, who held court in the inn's parlor (seen here on a 1930s postcard).

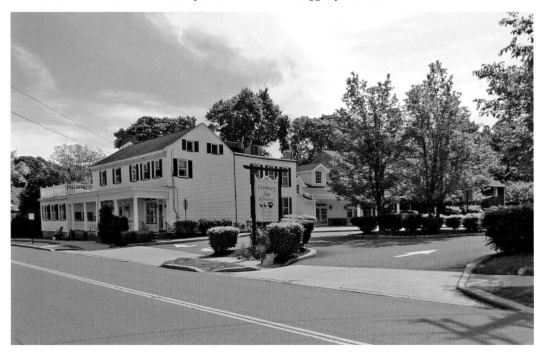

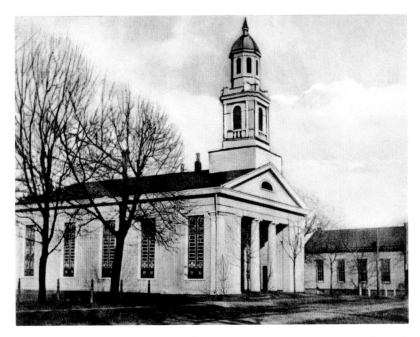

FIRST PRESBYTERIAN CHURCH OF CRANBURY: Organized in the mid-eighteenth century, the current building dates to 1839. The present basic floor plan was reached after extensive additions were made in 1859. The church originally had a nearly 140-foot steeple which was destroyed during a storm in 1898. The subsequent repairs resulted in the more conservative steeple as pictured here in the 1920s. The parish counts many local Presbyterian congregations as offshoots.

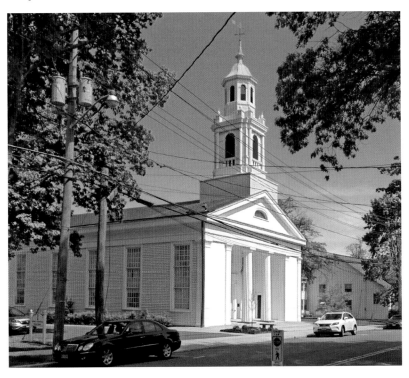

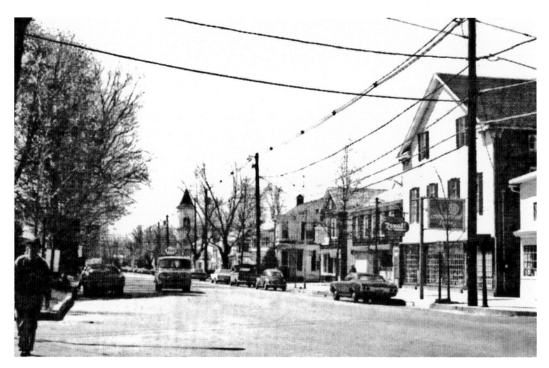

NORTH MAIN STREET: This comparison of an early 1970s view of the quaint tree-lined main thoroughfare through Cranbury shows few outward changes to the buildings and ambiance. Like many towns with a main drag abundant with pedestrians and automobiles alike, the township has followed the modern trend of installing bottlenecks at selected intersections to force drivers to be mindful of their surroundings and yield to foot traffic.

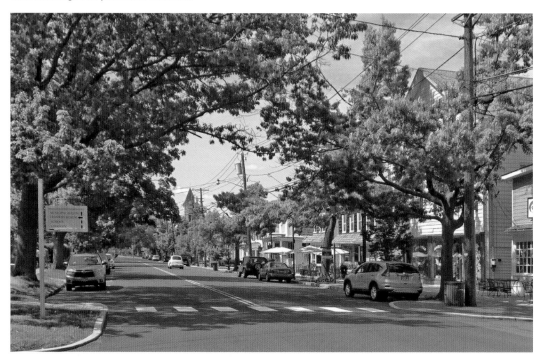

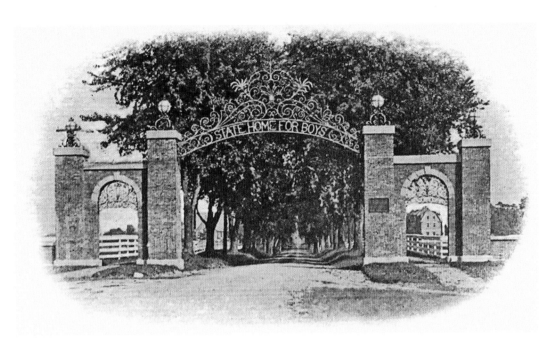

STATE HOME FOR BOYS: The Monroe Township facility was opened in 1866 as a reformatory for troubled adolescents. Boys were sent there for charges such as truancy, theft, incorrigibility, and general delinquency. As of 2018, the facility (now known as the New Jersey Training School) is a secure correctional/vocational facility which houses approximately 200 males mostly between the ages of sixteen and eighteen. Pictured early in the twentieth century, the future of the institution is uncertain, as a reformation plan of the state's juvenile justice system laid out in January of 2018 calls for the eventual closure of the complex.

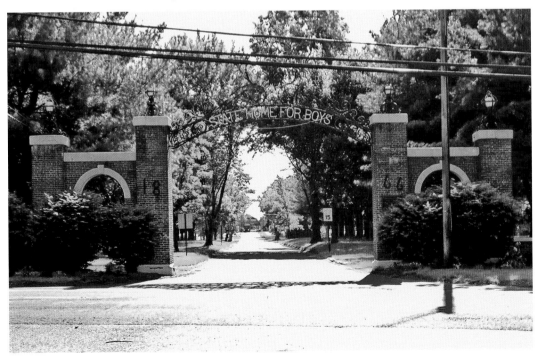

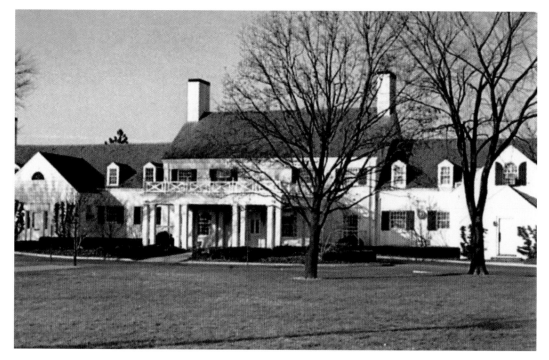

FORSGATE COUNTRY CLUB: Scottish immigrant and entrepreneur James Forster purchased 50 acres of land in Monroe Township in 1913 and set up a dairy farm which he named *Forsgate Farm* after a combination of his and his wife's (Gatenby) surnames. In 1929; Forster, a lifelong golfer, decided to open his own club. He employed Clifford Wendehack to design the colonial clubhouse, and famed golf course architect Charles Banks to design the course. Both Forster and Banks died before the club opened in 1931. A secondary course was laid out in 1961 (about the time of this photo) and has been revamped and expanded upon several times.

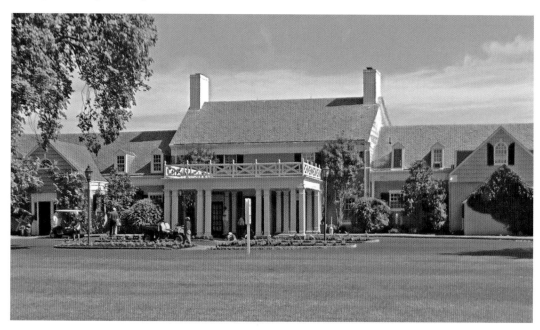

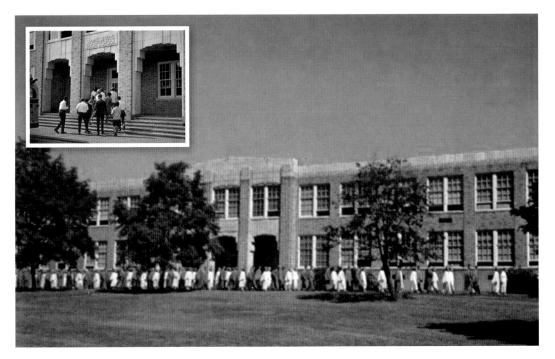

JAMESBURG HIGH SCHOOL: Built in 1931-2, this building replaced a much smaller high school which opened in 1912. The school (seen here in two views from 1960) cost $165,000 to construct, and at the time of its completion, boasted some of the most modern accommodations for the student body. Enrollment steadily declined through the 1970s, and the state closed the school after the 1978-9 school year. Soon thereafter, the school was remodeled into office suites and reopened as the Forsgate Commons.

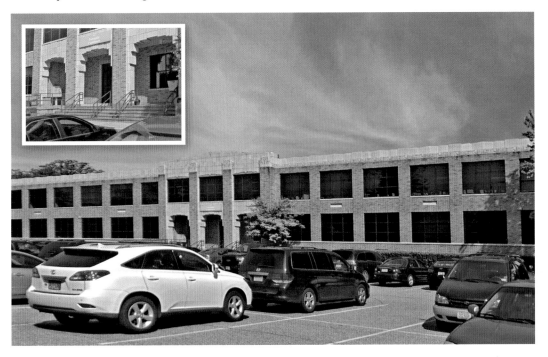

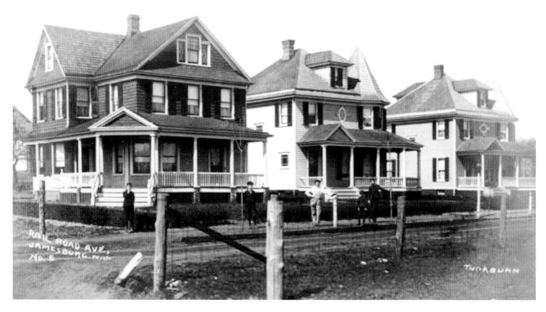

RAILROAD AVENUE: Neighborhood kids assemble outside of their family homes in this 1910s view of West Railroad Avenue in Jamesburg. Remarkably intact, this block of homes is anchored at the right corner by the former Star Theater (not pictured), which was sold to the Jamesburg Elks in the late 1950s, and has since served as their lodge.

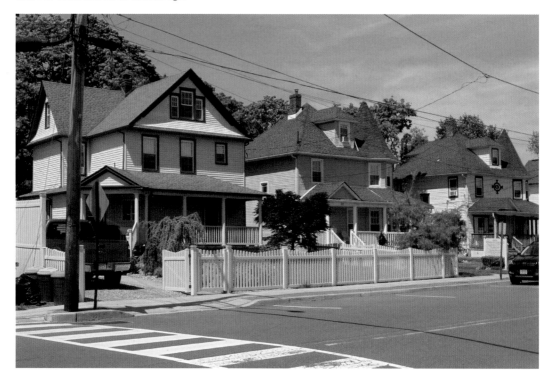

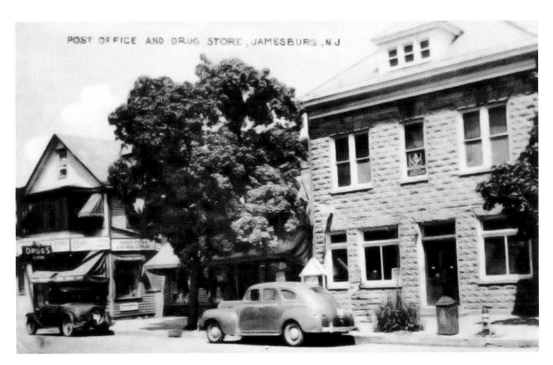

WEINRAUB DRUGS AND THE JAMESBURG POST OFFICE: Pharmacist Samuel Weinraub opened his drug store on East Railroad Avenue in the late 1930s, two doors down from the post office, seen here in a 1940s postcard. The post office was built in 1909, and served in that capacity until 1962, when a new office was opened down the street. The structure was then purchased by the borough and used as the Jamesburg town hall and police station until 2000, when the borough moved their operations to the current location on Perrineville Road. The building presently is home to a daycare/preschool.

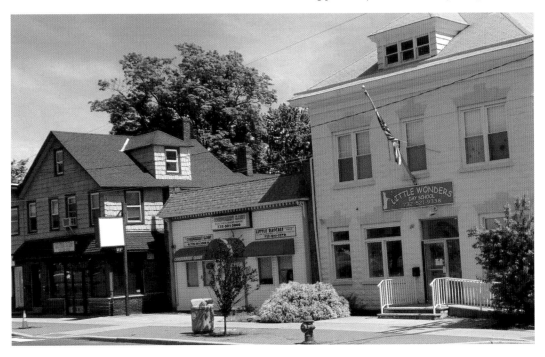

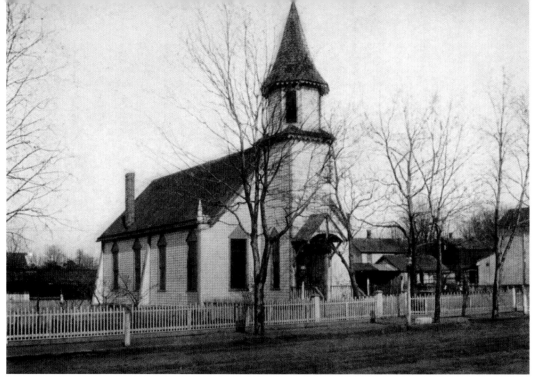

THE GERMAN BAPTIST CHURCH: The church was built in 1886-7. George Helme, owner of a nearby snuff mill (see page 35), had many German immigrants working in his factory and contributed the bulk of the funds needed to construct the building, pictured in the early 1900s. The congregation outgrew the edifice over the next century, and relocated in 1976. In the early 1980s, the borough purchased the building and converted it into a senior center, for which it is still utilized.

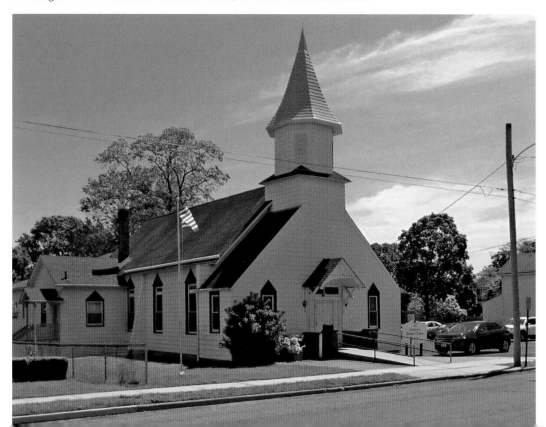

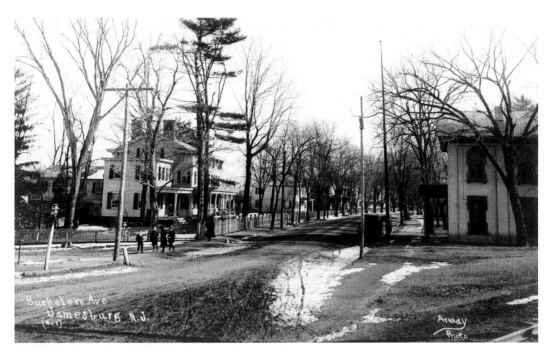

THE LAKEVIEW MANSION AND BUCKELEW AVENUE: James Buckelew, the namesake of both Jamesburg, and more obviously, Buckelew Avenue, was a miller and farmer who purchased the gristmill on Lake Manalapan in 1832. He moved his family into the miller's homestead, which, as legend has it, started as a one-room hovel in the late seventeenth century. Buckelew considerably expanded the homestead, and additions continued after his 1869 death. The building at right in the early twentieth century view was demolished in the mid-1950s, allowing for widening of the intersection of Buckelew and Pergola Avenues.

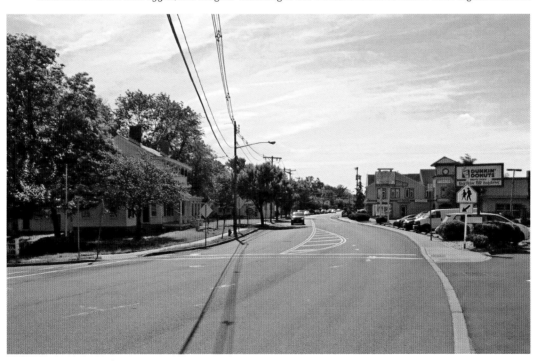

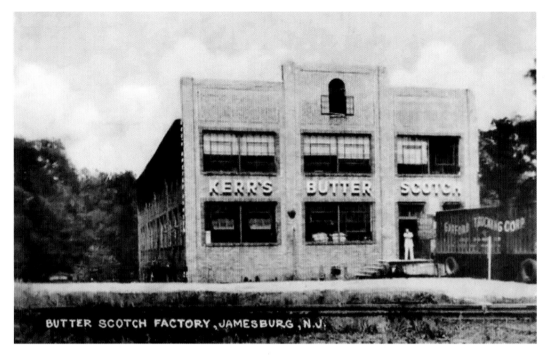

BUTTER SCOTCH FACTORY, JAMESBURG, N.J.

KERR'S BUTTERSCOTCH FACTORY: Jamesburg's eighteenth-century gristmill, altered and expanded several times, burned to the ground in 1898. A silk mill was erected in its place shortly thereafter, which also burned to the ground less than a decade later. Edward and Albert Kerr, Scottish transplants to Toronto, Canada, decided to expand their confectionery business into the United States and built a factory on the site in 1907. The Kerr factory (pictured in the 1940s) remained stateside exactly fifty years, closing its doors in 1957. As of 2018, Kerr's is still in business in Toronto. The factory was subsequently converted into office space.

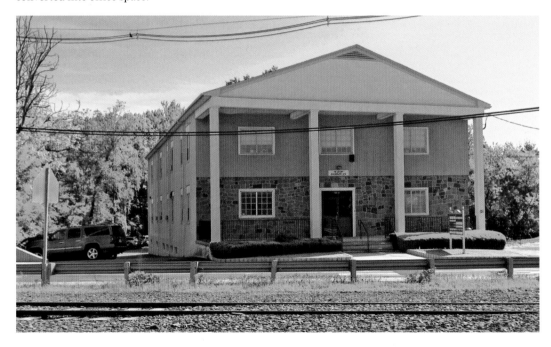

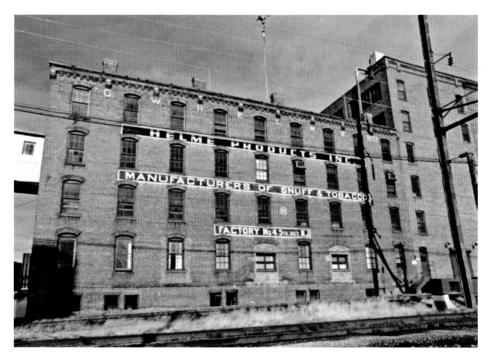

GEORGE W. HELME SNUFF FACTORY: Leonard Appleby purchased an old distillery operation in 1825 in what was then Monroe Township. At the time, snuff (pulverized tobacco leaves which are snorted up the nose) was very popular, and Appleby set up a mill there. Former Confederate General George Washington Helme married Appleby's daughter, and joined the firm shortly after the Civil War, becoming sole proprietor by 1872. In 1883, he constructed a modern mill (pictured in 1978) fronting the tracks. The company moved to West Virginia in 1993. The mill was converted into rental lofts from 2013-7, and has proven to be a success story in adaptive use.

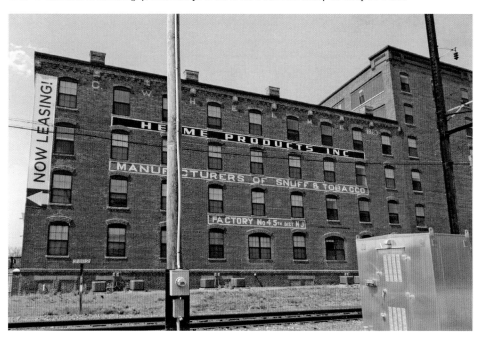

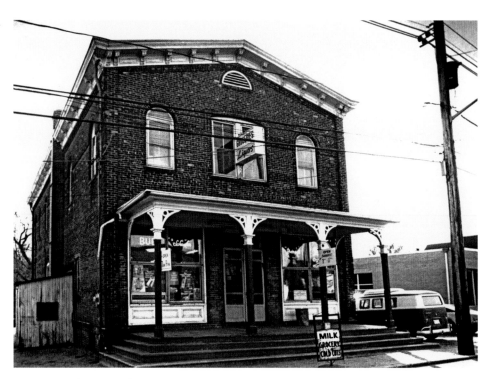

HELMETTA GENERAL STORE: The borough of Helmetta was formed around the snuff mill in 1888. George Helme strove to offer his workers a comfortable and enjoyable life outside the job. He contributed funds to build amenities, churches, and schools in Helmetta and the surrounding communities. This general store was built opposite the factory complex shortly after the mill's completion in 1883. Pictured in the 1970s, the building is currently home to a pizzeria.

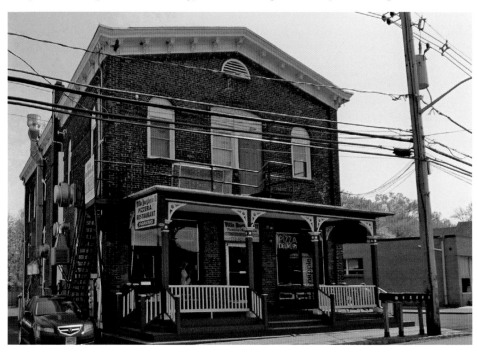

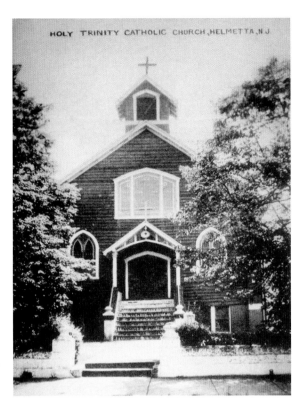

HOLY TRINITY CATHOLIC CHURCH: Built in 1911, the Catholic church has changed very little over the past century. Affiliated with the Diocese of Metuchen, which was established in 1981, the congregation has seen a recent influx of new parishioners with the conversion of the snuff mill into residential units. Pictured on a 1940s postcard, the church is a perfect example of small-town Americana.

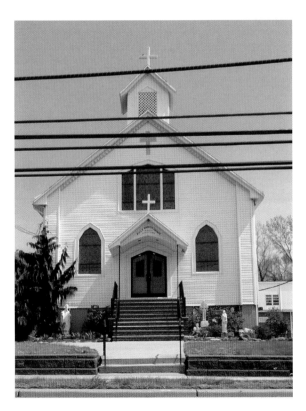

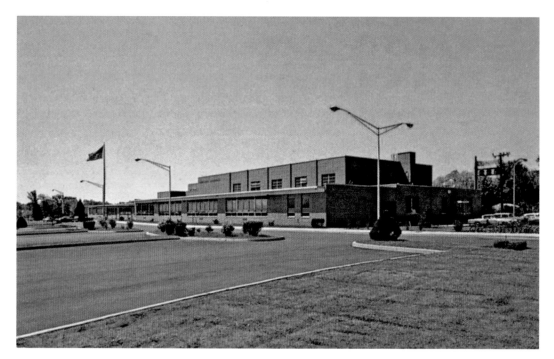

IMMACULATE CONCEPTION CHURCH AND SCHOOL: The Spotswood mission was set up in the 1940s and officially incorporated into the Diocese of Trenton in 1948. After moving through a few different locations in the borough, the congregation purchased 14 acres on DeVoe Lake in 1955. Five years later, at a cost of $1.5 million, the complex (which includes a school) was opened (pictured here, shortly after dedication). The mid-1980s saw the completion of a new rectory and youth center. As the comparison illustrates, the center has maintained the same physical outward appearance for nearly sixty years.

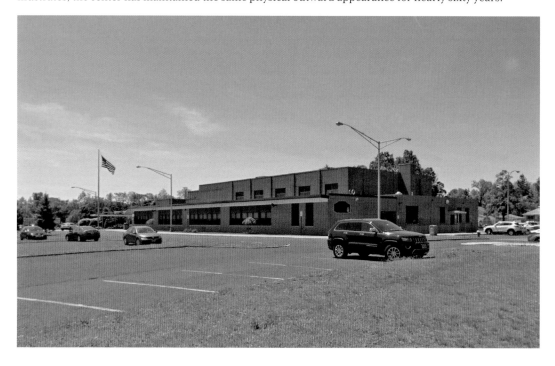

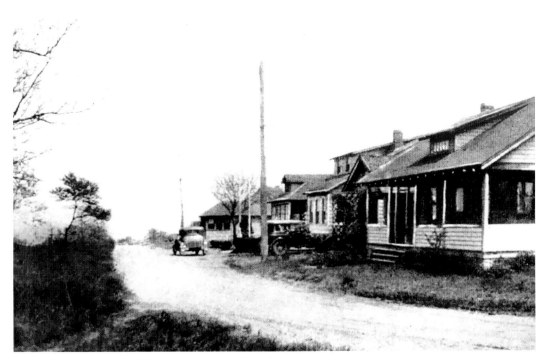

SHORELAND CIRCLE: Situated at the tip of the Laurence Harbor section of Old Bridge, this waterfront thoroughfare has undergone only superficial changes in ninety years. The area is one of the first sections of New Jersey in which Europeans permanently settled. The seventeenth- and eighteenth-century homesteads of the Bowne and Provost families were located on the bluff very near to this neighborhood. In fact, the photos presented here are taken from the edge of their family burial ground. The few legible stones remaining date from the eighteenth century.

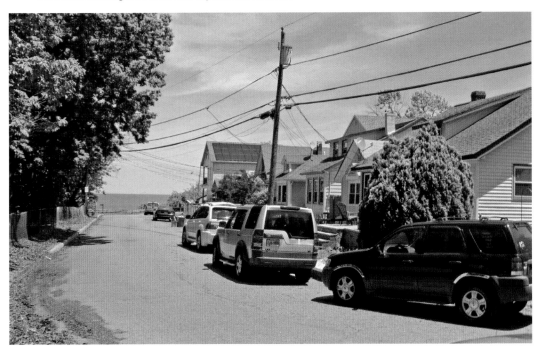

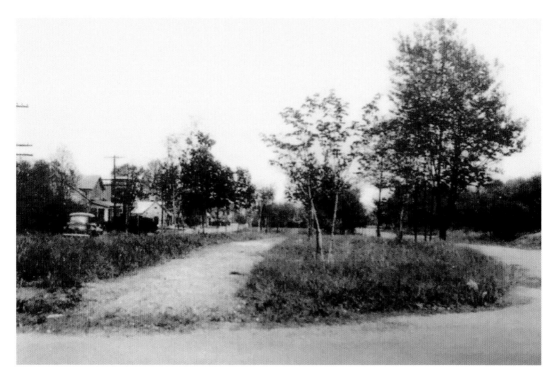

THE PATH: The small, narrow park running down the middle of Laurence Parkway was contrived when Laurence Harbor was laid out in the early twentieth century. The original area of the commons has been whittled down due to road widening, when compared to a 1930s image. The small cluster of houses seen at left were the first dwellings built in the neighborhood, and have witnessed an entire suburbia bloom in all directions around them.

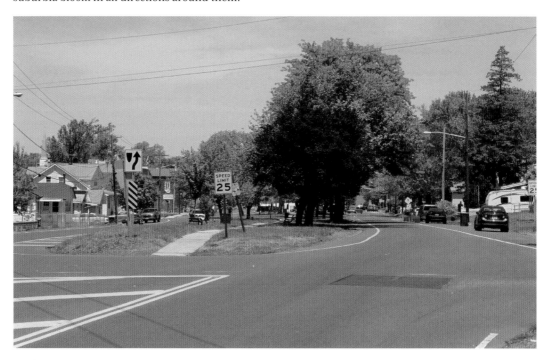

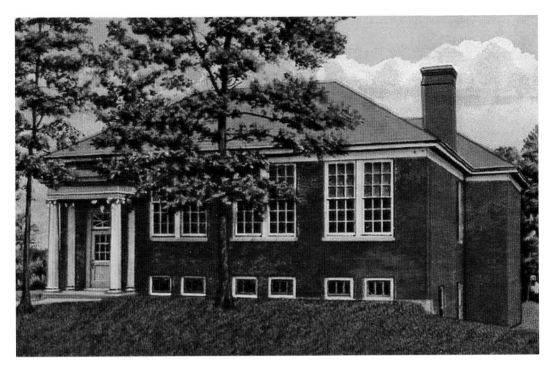

LAURENCE HARBOR SCHOOL: Constructed early in the twentieth century, the institution served the children of Laurence Harbor for fifty years, until Memorial Elementary School was built in the 1950s. The building was then converted to municipal use, serving as the town library, then as the Old Bridge social services center. Most recently, the building has been utilized as the office for senior services. As of 2018, it appears to have limited usage as such with a larger office recently dedicated elsewhere in the township.

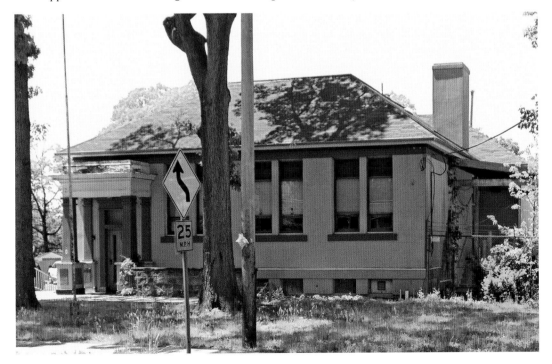

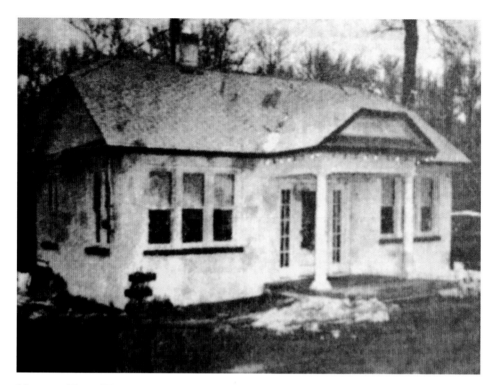

MADISON TOWN HALL: Old Bridge was originally incorporated in 1869 as Madison Township. A rural collection of farming communities, the town's first base of operations (pictured here in the 1950s) was constructed in the 1910s on Route 516. A new complex was completed in the 1960s, and this building and the property it sits on have since been used as storage for police and public works vehicles and equipment. Madison Township officially adopted the name of Old Bridge in 1975.

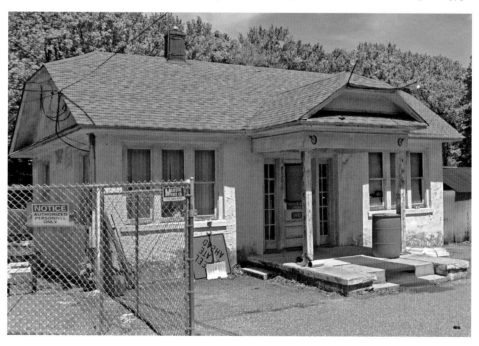

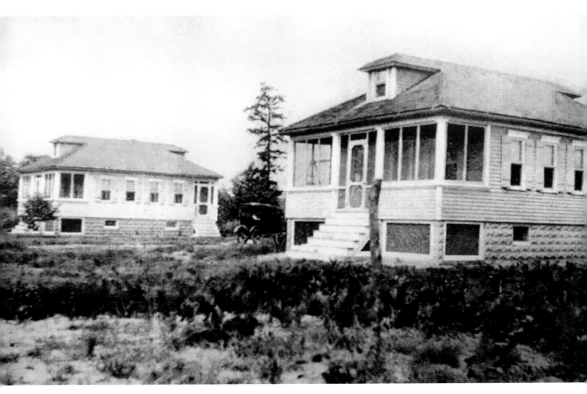

OAK STREET: Brunswick Gardens was one of the first residential developments cut out of the sprawling farm and woodlands which made up the bulk of Madison Township. Most of the original buildings were constructed in the first quarter of the twentieth century. These two dwellings, pictured about 1915, are among the few surviving remnants of the genesis of the neighborhood which has been developed quite extensively over the past few decades.

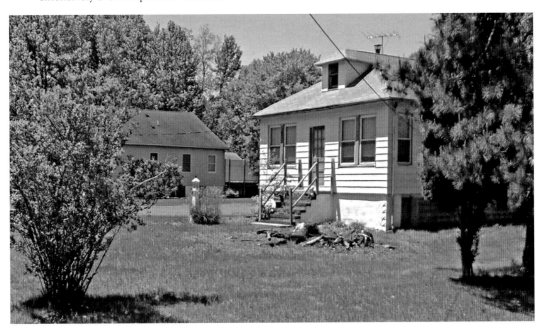

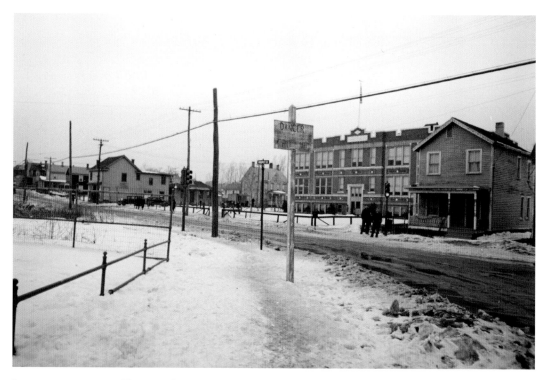

LOOKING WEST FROM THOMAS STREET: Reid and Thomas Street fork together to form Prospect Street in South River, as seen in this wintery view from 1936. At right center in the vintage view is Public School #3, known also as Lincoln School. The school was constructed in the early 1900s, and stood abandoned for many years prior to being demolished in 2017. The site has been earmarked for a mix of residential and commercial development.

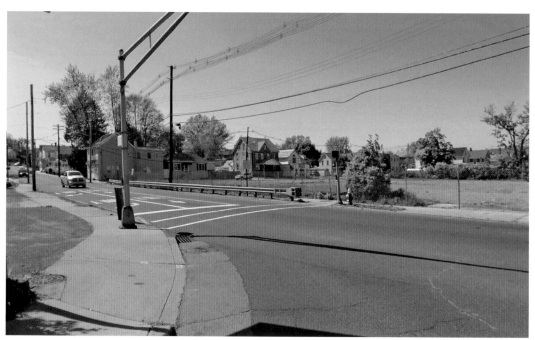

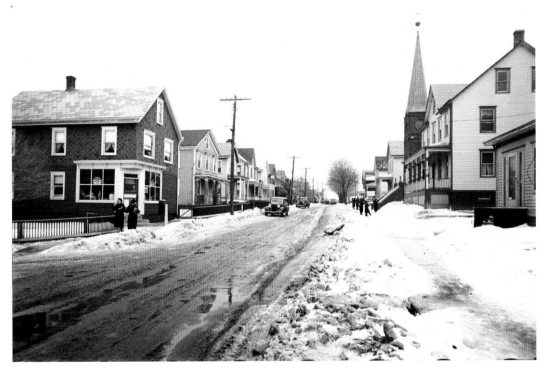

LOOKING EAST FROM THOMAS STREET: This image was taken at the same time and location as the image on the preceding page, looking in the opposite direction. Other than the snow on the ground, there is hardly any difference in the scenery on this stretch of Thomas Street. At right is the First Reformed Church, which was built in 1906 and has long been a cornerstone of the local Hungarian community.

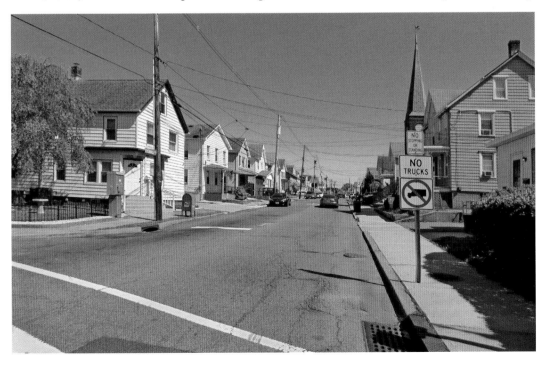

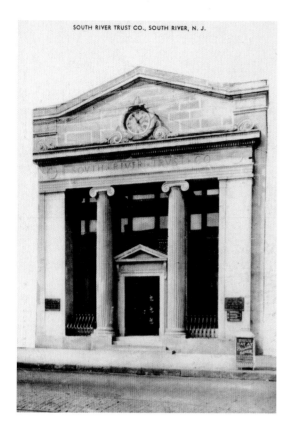

SOUTH RIVER TRUST COMPANY: The building was erected in 1920, five years after the institution's incorporation. Like many financial firms, the company struggled after the stock market crash in 1929. In June of 1931, the state took over the trust, and began liquidation procedures. The liquidation was delayed, and proposals were submitted to the state banking commission which restructured and saved the institution (seen here *c*. 1940). Like many local banks, the South River Trust was absorbed into larger banks over the decades. As of 2018, the last tenant of the property was Bank of America, which closed the branch three years ago.

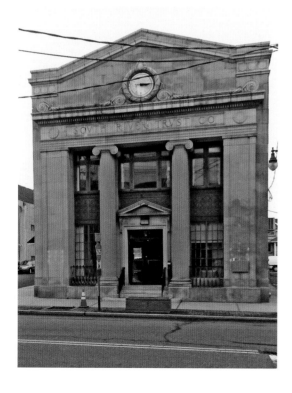

UNITED METHODIST CHURCH OF SAYREVILLE: Organized in the 1840s, the church was constructed in 1869 using Sayre and Fisher bricks. Peter Fisher and his family were active members of the congregation, the oldest religious outfit in Sayreville. The church was expanded considerably in 1895. Viewed in the 1910s, the spire was removed after storm damage in the 1940s.

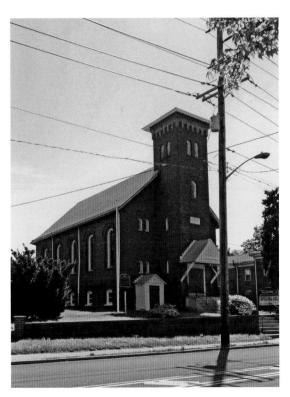

SAYRE & FISHER READING ROOM: Sayreville is named in honor of the S&F brick company, which was founded in 1850 by James Sayre and Peter Fisher. The firm constructed a community center in 1883 on the corner of Main Street and River Road as both a means of giving back to the community and advertising all of the different specialties and colors of bricks the company produced. Viewed here in the 1970s, the building today houses a catering operation and apartments.

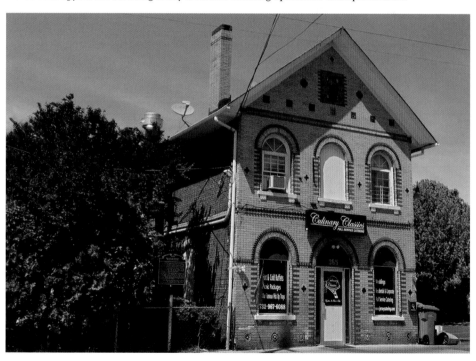

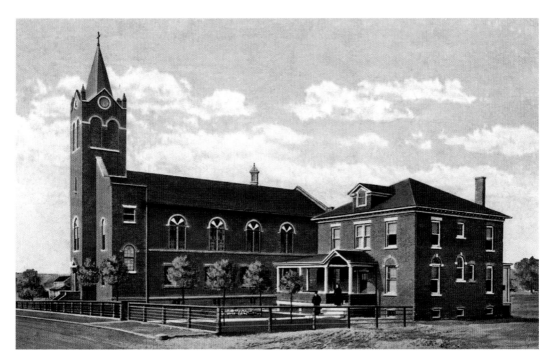

ST. STANISLAUS KOSTKA CATHOLIC CHURCH: Many Polish immigrants settled in Sayreville in the first quarter of the twentieth century, attracted by the ample work offered by the brickyard. The building was designed by local architect William Endelbrock in 1915, and Joseph Check was the contractor and construction foreman. A school was also set up which initially operated out of the basement of the church. The school continued to grow, and in 1964 a separate building was constructed on church grounds. The entire complex was built with Sayre and Fisher bricks.

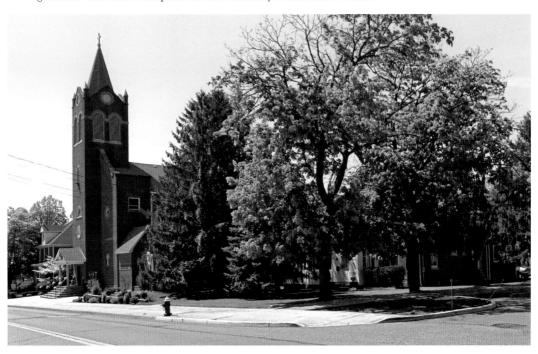

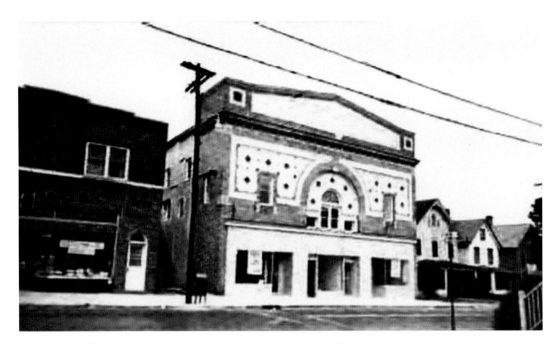

THE COLONY THEATRE: Built shortly after the conclusion of World War One on Main Street in Sayreville, the venue was aptly named the Liberty Theatre. Financial issues during the Great Depression forced the closure of the cinema. It reopened in 1939 as the Colony Theatre and closed again in the 1950s. The photo here was taken shortly after the theatre was closed. The building was then purchased and split into commercial and residential units.

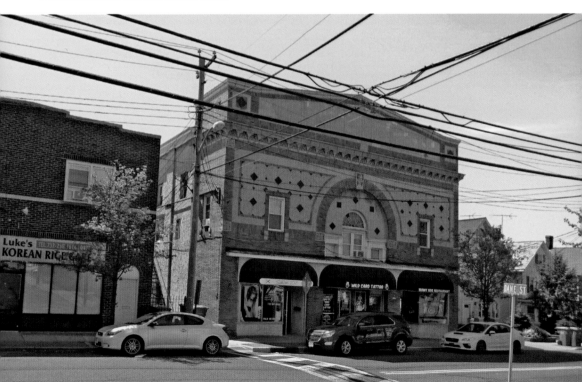

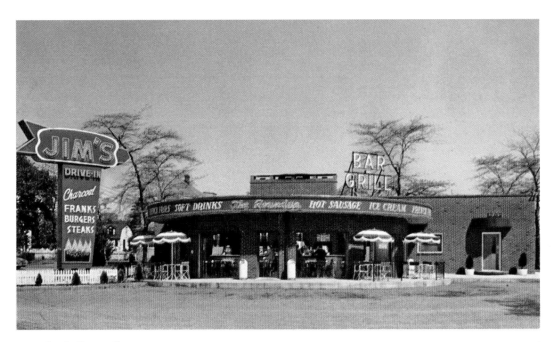

JIM'S DRIVE IN: The distinctive restaurant was built in 1954 on Route 35 in the Morgan section of Sayreville. This postcard dates from within the first few years of operation. The restaurant has changed hands many times over the past six decades, but due to the key position near the Cheesequake bridge, the location generally does not remain vacant long.

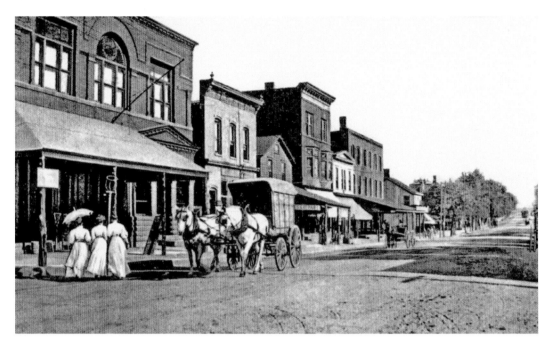

BROADWAY: One of the few stretches of the main drag in South Amboy which is somewhat recognizable. Although many old buildings still stand on Broadway, it is rare to find a whole block, such as this one at the intersection with David Street, where the scenery somewhat remains intact from a century past. This comparison with a postcard image from the early 1900s would be more effective if there were fewer trees.

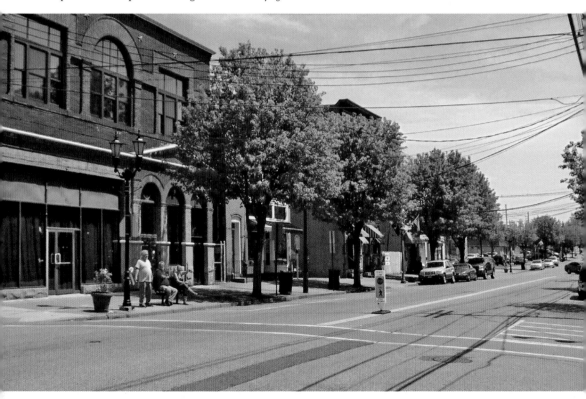

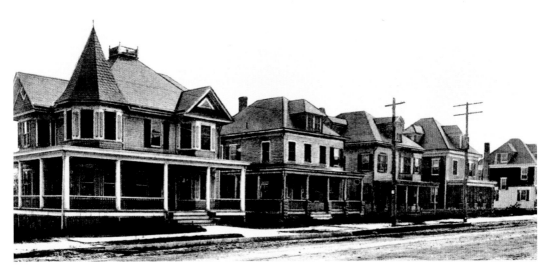

MAIN STREET: Unlike Broadway, Main Street in South Amboy has remained incredibly intact. This 1920s image illustrates the point perfectly. Nearly every building remains with little to no alteration. Main Street was originally laid out as the city's primary route, but it was soon eclipsed by Broadway which offered businesses more space to expand at lower lease prices.

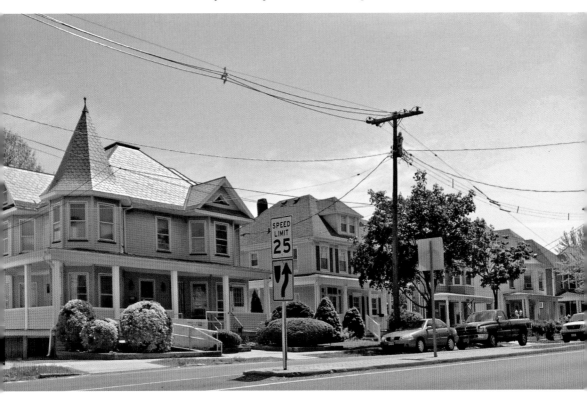

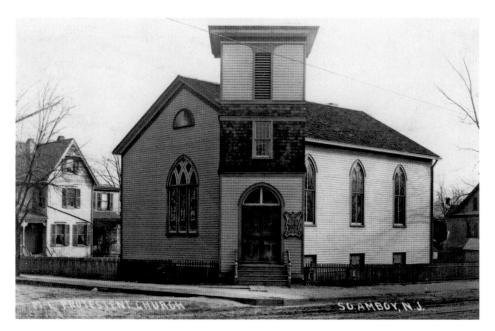

SOUTH AMBOY METHODIST CHURCH: Constructed in 1868, the building originally had a simple house-shaped design, and it lacked its distinctive corner entrance. This early 1900s postcard view captures the church shortly after the alteration was made. In the 1920s, a steeple was added. In the mid-1960s, it was deconsecrated as a church and was adapted for use as a library. The Middlesex County Chapter of the Ancient Order of Hibernians purchased the building in 1997.

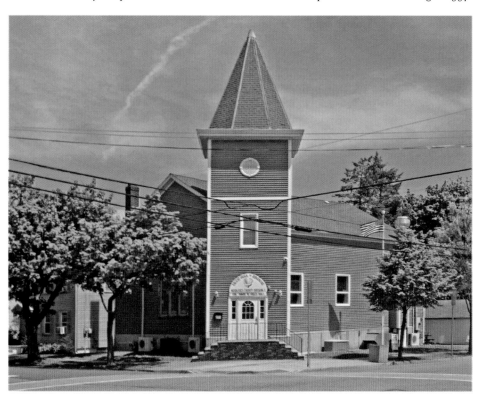

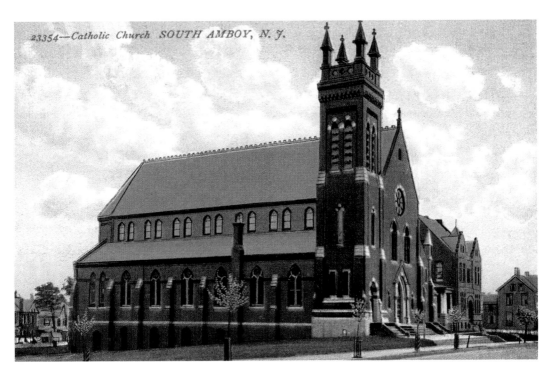

23354—*Catholic Church* SOUTH AMBOY, N. J.

SAINT MARY'S ROMAN CATHOLIC CHURCH: Pictured on a 1930s postcard, it is the largest church in South Amboy. Constructed from 1873-6 at a cost of $80,000, the present church replaced a much smaller building on this site. Saint Mary's sustained considerable damages when a massive series of explosions lasting three days at the T. A. Gillespie Munitions Company in Sayreville occurred in October 1918. In 1950, another munitions explosion—420 tons of military explosives—at the rail docks on the Raritan River also badly damaged the church, and services had to be conducted outside until repairs were completed.

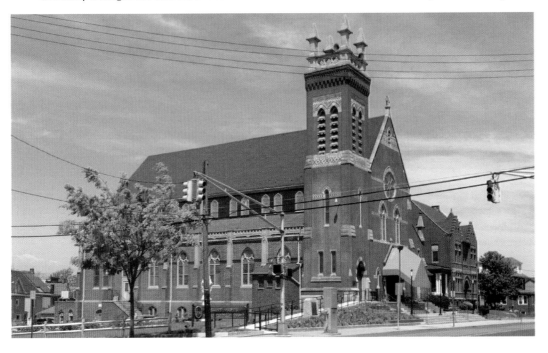

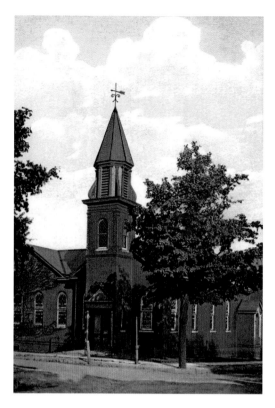

FIRST BAPTIST CHURCH: Built in 1873, the South Amboy Baptist community saw a steady decline in the last quarter of the twentieth century. In the early 2000s, the congregation merged with the Perth Amboy Baptist Church. The Everlasting Strength Ministries began as a Bible study program in 2001. Initially held in a small room in a Woodbridge bookstore, membership quickly outgrew several smaller locations, which led to the 2008 purchase of the Baptist church building, their current home.

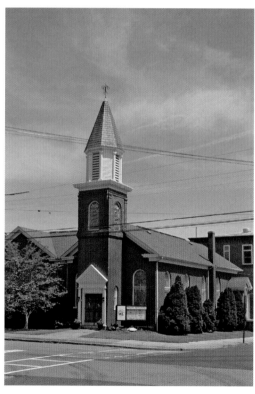

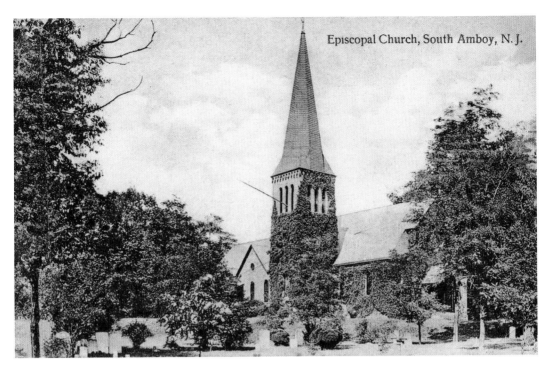

Episcopal Church, South Amboy, N. J.

CHRIST EPISCOPAL CHURCH: The oldest congregation in South Amboy, it was founded by the Stevens family. The church was built in 1858, and originally was named Saint Stephen's (possibly as a nod to the powerful Stevens family). The view here is from the early 1920s. Parishioners were originally interred around the perimeter of the church, a practice which was abandoned when the church purchased a nearby tract for use as a burial ground. While some graves remain at the church, others have been moved to the cemetery,

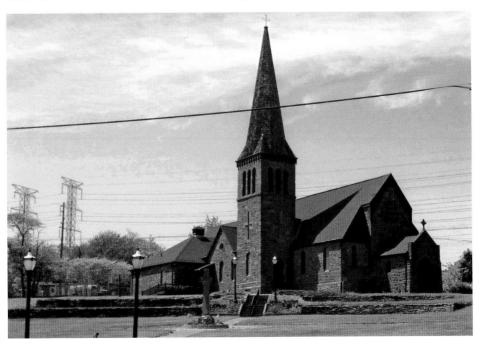

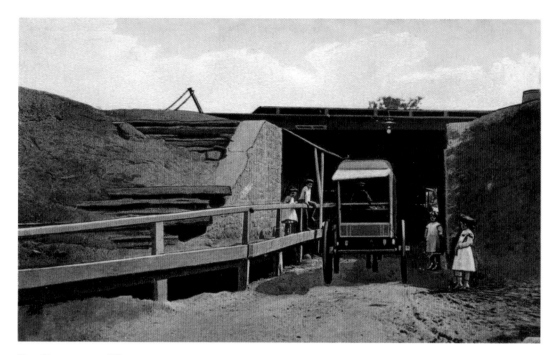

THE HOLE IN THE WALL: Bisecting the six sets of tracks which converged at the Raritan River Railroad's Bergen Hill Yard, the underpass was constructed in the late nineteenth century to connect Mechanicsville to South Amboy. This view *c.* 1905 is taken from the Mechanicsville side. Looking at the modern photo, the lane on the left is the original path, as evidenced by the primordial wall of huge rough-hewn stone slabs lining the interior of that side. The corridor was widened in the mid-1920s with the automotive boom in full swing. A legendary site amongst the locals, structural issues have created tension between Conrail and the city of South Amboy. Only one set of passable tracks remain.

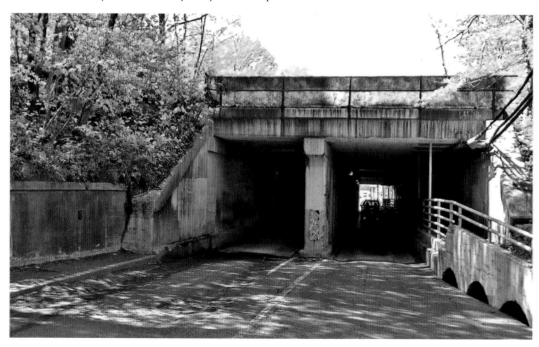

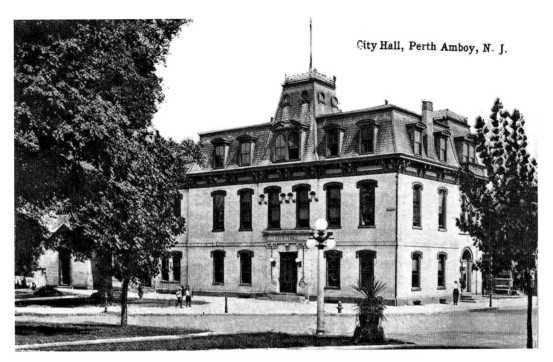

City Hall, Perth Amboy, N. J.

CITY HALL: Perth Amboy has the oldest city hall continuously in use in the United States. Initial construction took place from 1714-7. Two major fires in the eighteenth century required reconstructive repairs. The New Jersey Legislature, meeting here, was the first legislative body to ratify the Bill of Rights in 1789. An 1870 Victorian overhaul gave the structure its present outward appearance, seen here *c.* 1910. In 2016, a major renovation modernized and secured the structure without changing the historic outward appearance.

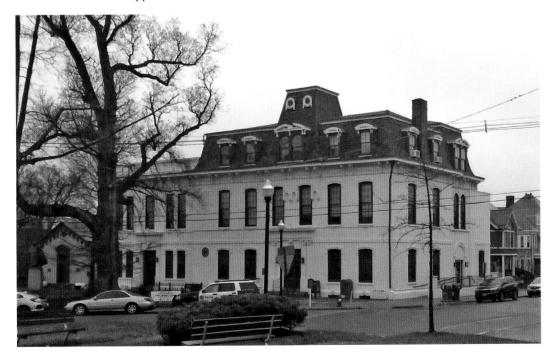

PROPRIETARY HOUSE: Built from 1762-4, this is the only proprietary governor's mansion from the original thirteen colonies still in existence. Royal Governor William Franklin (son of Benjamin Franklin) was living there when he was arrested by the Provincial Congress of New Jersey in 1776. The patriots burned the mansion during the revolution. John Rattone purchased the property in 1794 and refurbished and expanded the building, reopening it as the Brighton Hotel. The property passed through several owners, and eventually became a retirement home for Presbyterian clergy. It has served as a museum since 1914 (pictured thereabout), and has been under restoration since 2011.

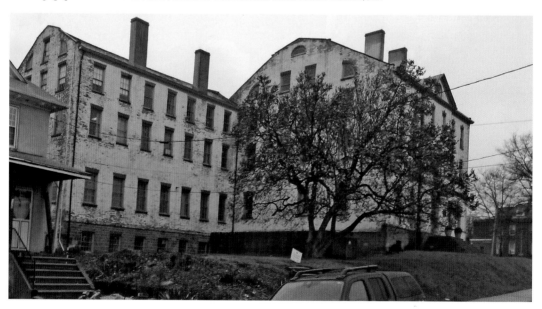

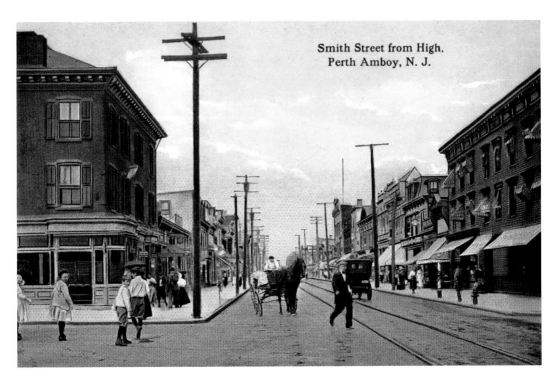

Smith Street from High,
Perth Amboy, N. J.

SMITH AND HIGH STREETS: Perth Amboy intersection, as viewed in the 1910s. While the southern side of the block remains essentially intact, there have been many changes made on the other side of the street. The building seen at right was demolished in the late 1960s, and a senior apartment high-rise complex was constructed in its place.

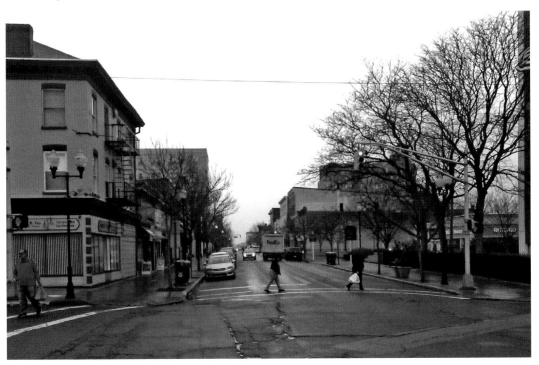

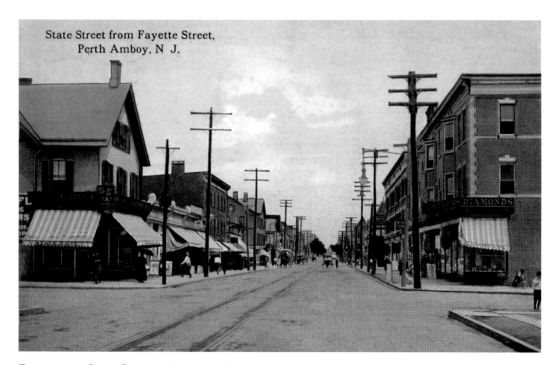

State Street from Fayette Street,
Perth Amboy, N J.

FAYETTE AND STATE STREETS: Another Perth Amboy juncture, as documented on a late 1910s postcard. Much like the comparison on the preceding page, one side of the street remains remarkably intact, while the other has been greatly altered for the construction of a high-density residential conglomeration. The entire block bound by Division, Fayette, Broad and State Streets was demolished in the early 1960s to make way for the State Fayette Garden Apartments, which were completed by 1968.

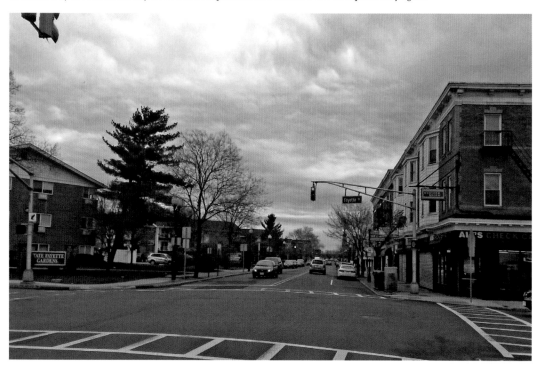

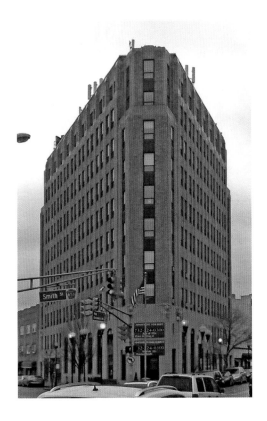

PERTH AMBOY NATIONAL BANK, PERTH AMBOY, N. J.

PERTH AMBOY NATIONAL BANK: The tallest building in Perth Amboy, the ten-story landmark was constructed in 1929 at the Five Corners as headquarters of the Perth Amboy National Bank. Viewed on a 1940s postcard, the Perth Amboy bank was absorbed into larger state and national banks over the decades, and the building began to lose occupancy. By the 2000s, the top five floors were vacant. In 2016, Eddie Trujillo of ETC Management purchased the building, with intent on converting the vacant floors into senior housing.

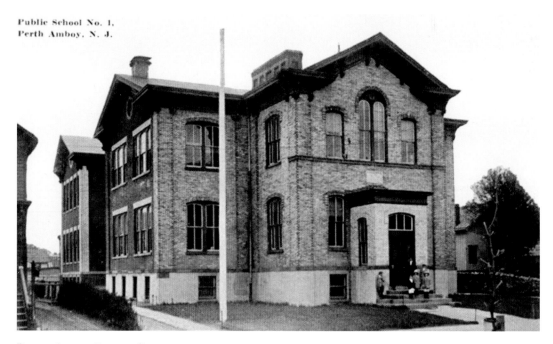

Public School No. 1,
Perth Amboy, N. J.

PERTH AMBOY PUBLIC SCHOOL: Built in 1871, this was the first public school constructed in Perth Amboy. Pictured on an early 1900s postcard, the building was renamed in 1989 after Thomas Peterson, who was the first African American to vote in a federal election after the passage of the Fifteenth Amendment. Peterson long served as the custodian for the school. The building is currently an annex to the McGinnis Middle School, directly across State Street.

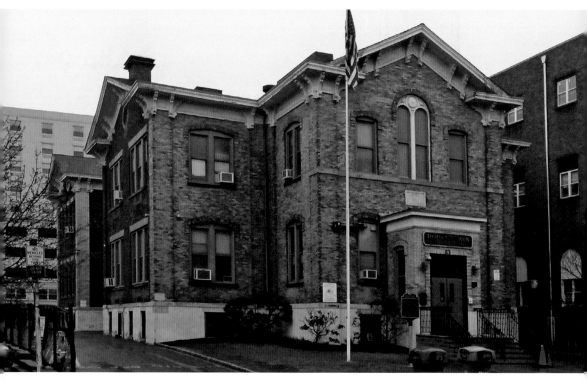

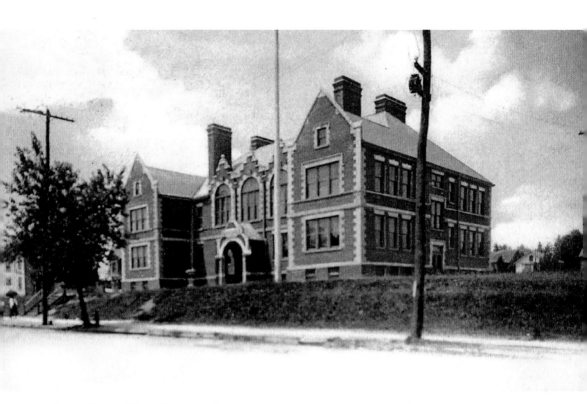

PERTH AMBOY HIGH SCHOOL: The distinctive State Street school was built in 1897-8, seen here *c.* 1910. In 1971, a new high school was built on Eagle Avenue and this complex has since been utilized as the city's middle school. It was named after Dr. William C. McGinnis, who served as the Superintendent of Perth Amboy Schools from 1930-53. Dr. McGinnis also published several histories of Perth Amboy and the Perth Amboy School District. Additions and renovations were made to the building in 1995.

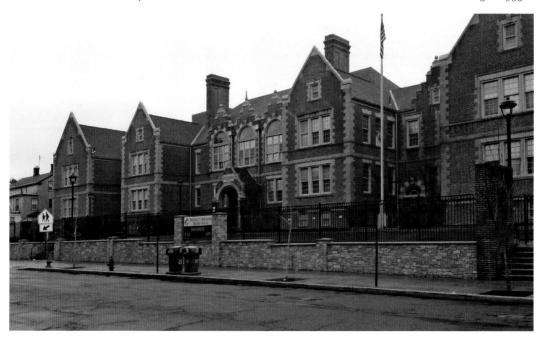

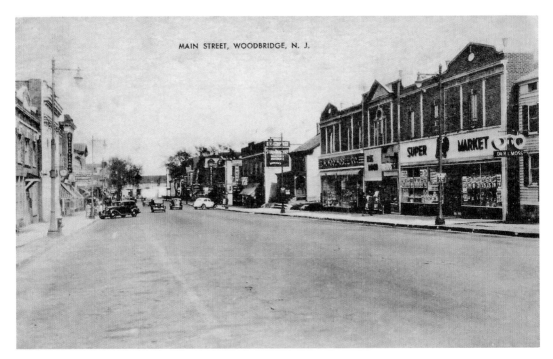

MAIN STREET, WOODBRIDGE, N. J.

MAIN STREET: Woodbridge's main thoroughfare is pictured in the 1940s. Although partially obscured by trees, the northern side of the block remains mostly intact in this photo comparison. If it weren't for the brick building (97 Main Street) at right center, the south side would not at all be distinguishable in the comparison. The buildings at the right in the 1940s view were demolished and rebuilt in the late 1980s.

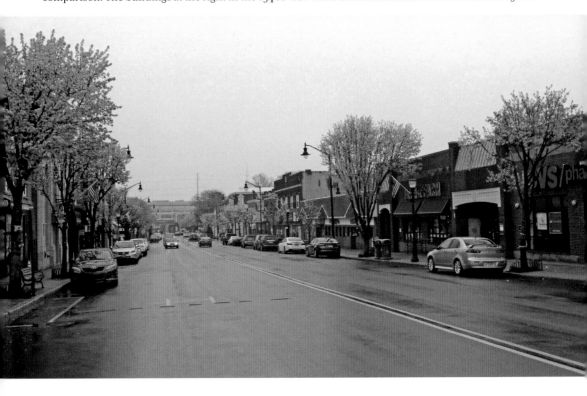

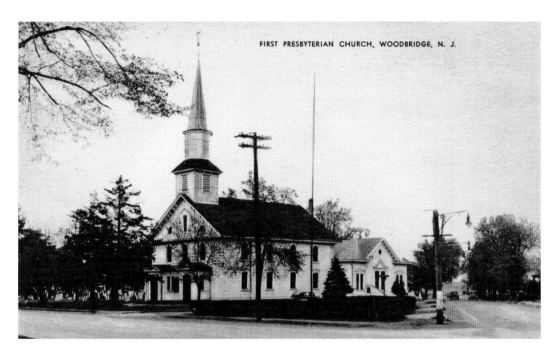

FIRST PRESBYTERIAN CHURCH, WOODBRIDGE, N. J.

FIRST PRESBYTERIAN CHURCH: Woodbridge is the oldest original township in the state of New Jersey, having been chartered in 1669. The Presbyterian congregation there was established shortly thereafter, in 1675. The oldest legible gravestone in the church cemetery is dated 1690. The current church, pictured here in the 1940s, was built in 1803 on the site of a much more rudimentary structure. An 1870s renovation included extensive remodeling of the church features, and a century later in 1972, a further (more preservatory) renovation was performed.

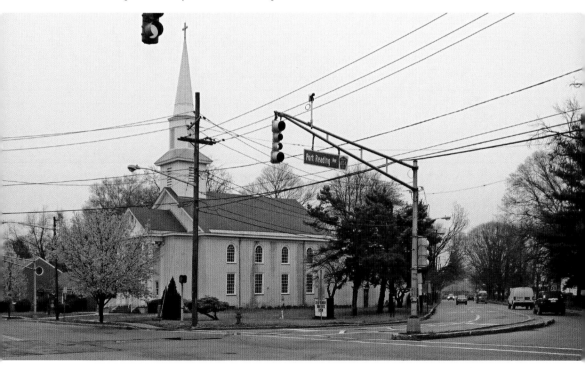

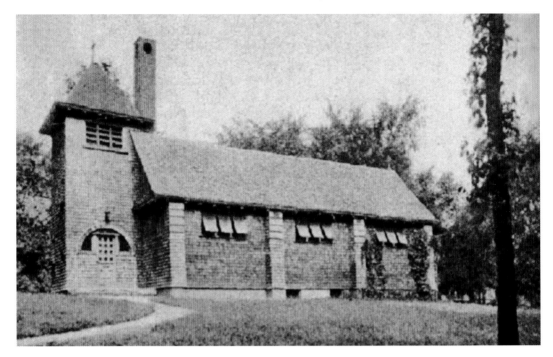

SAINT JOHN'S EPISCOPAL CHURCH: Nestled on a corner lot on the bluffs of the Sewaren section of Woodbridge, the distinctive chapel was constructed in 1892, pictured within a few years of consecration. Although the Sewaren community was regarded as a more affluent neighborhood, the church experienced financial difficulties for decades after opening. They also faced great difficulty over the ensuing century in maintaining a permanent priest. In 2010, the congregation merged with the Fords Episcopal Church. The combined congregation worships in this building.

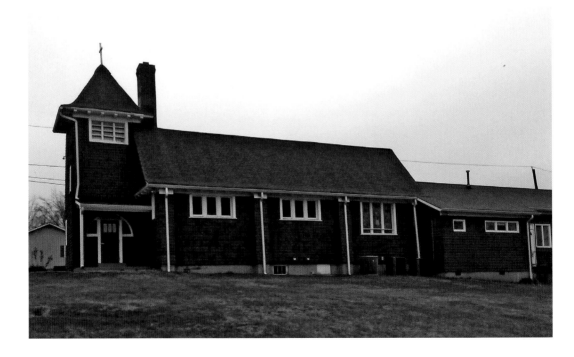

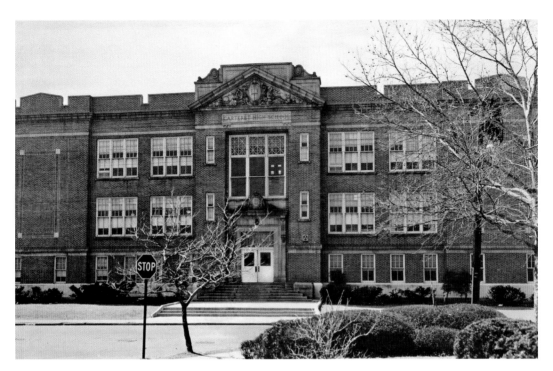

CARTERET HIGH SCHOOL: Constructed in 1929 on Washington Avenue, the school retains practically the same aesthetics as it did when compared to this photograph from 1959. Like many old buildings, the windows have had to be reframed in order to support modern windows. In recent decades, the school has been noted for its fine football program, having won sectional championships in 1992, 1996, 2007, and 2012.

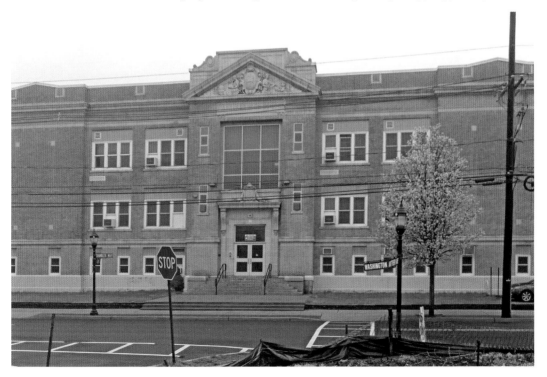

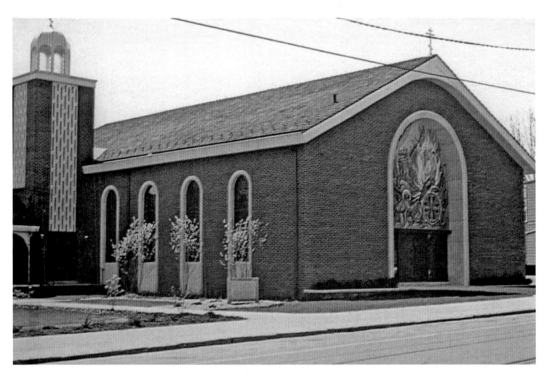

SAINT ELIAS BYZANTINE CATHOLIC CHURCH: The church was built in the 1960s (pictured shortly after completion) to accommodate the growing Greek and Turkish population in Carteret. A colorful mural fronts the main building on Cooke Avenue.

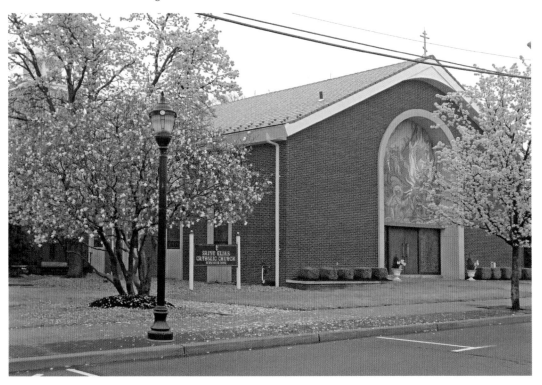

THE WIZARD OF MENLO PARK:
Thomas Alva Edison toiled endlessly
in his workshop in the Menlo Park
section of Raritan Township, coming
up with concepts and improving on
ideas to make life easier and more
enjoyable. Recorded sound, the light
bulb, batteries, motion pictures, and
Portland cement are among some of the
innovations devised or vastly improved
upon by Edison and his team. Very little
is left in Menlo Park which would be
recognized by the great man, save for
this monument at the location of his
former lab, for which he is pictured in
1925 at the dedication thereof. Raritan
Township renamed itself in Edison's
honor in 1954.

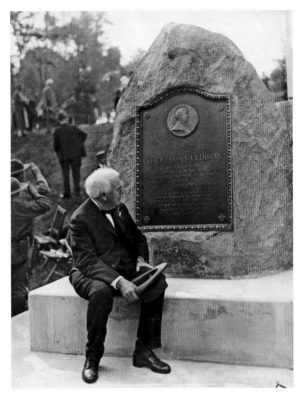

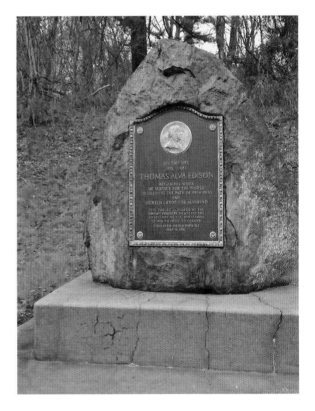

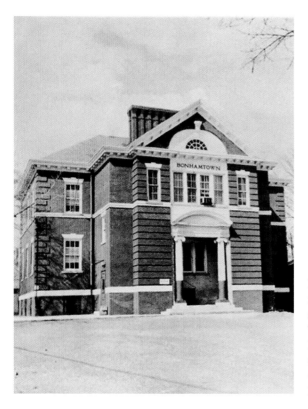

BONHAMTOWN SCHOOL: Built in 1908 in the center of the Bonhamtown section along Old Post Road and Woodbridge Avenue of what is now Edison, the charming school served elementary students for nearly a century. It is now the location of a Montessori school.

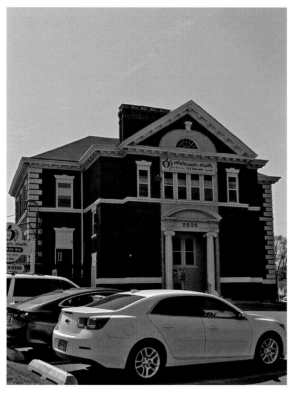

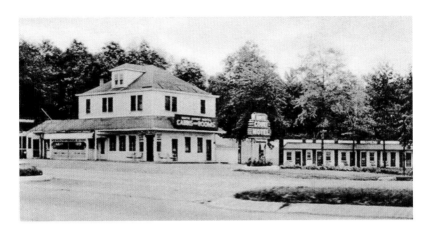

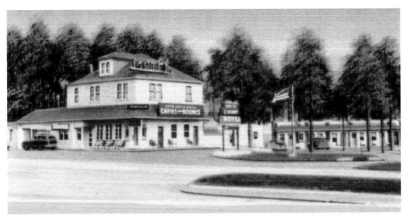

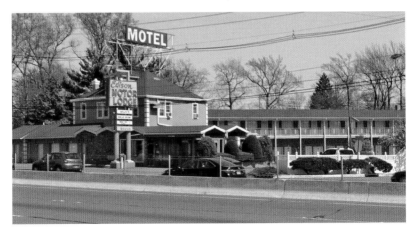

EDISON MOTOR LODGE: Built on Route One during the motel frenzy of the early 1950s, the lodge was originally named the White Court Motel. With Raritan Township renaming itself in Edison's honor, the motel followed suit in the early 1960s. A second story was added to the motel block, which was considerably expanded in the mid-1960s. The motel is pictured here on two promotional postcards, the first at top from the early 1950s, and the middle view about 1960. A four-alarm fire at the facility in 2007 led to an overhaul.

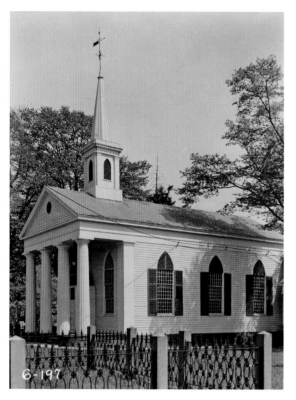

SAINT JAMES EPISCOPAL CHURCH:
The congregation formed in the early
days of the eighteenth century, and the
first church on these grounds situated
on Woodbridge Avenue was constructed
in 1724. The British used the church
as a barracks in the early days of the
Revolutionary War, destroying it in
1777 upon retreat. The church was
subsequently rebuilt, but destroyed
again, by a tornado in 1835. In 1836, the
present building was constructed using
timbers and sections from the earlier
buildings. The image here is from the
Historic American Buildings Survey,
taken in 1936.

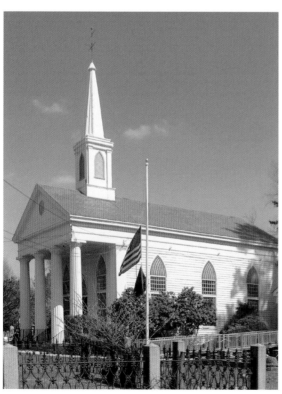

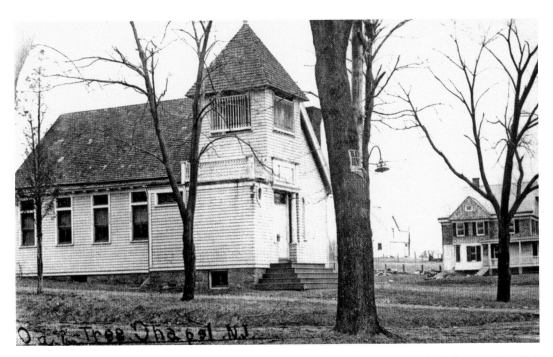

OAK TREE CHAPEL: Pictured on an early 1900s postcard, the chapel was built in 1895. The Oak Tree section of what is now Edison was named after a large oak which once stood in the center of the community. By 1933, the church was known as the Marconnier Reformed Church, which was another name that the Oak Tree neighborhood was known by, after a local farm which existed there. Dwindling membership forced the church to close, and the Edison Valley Playhouse took residency in 1965.

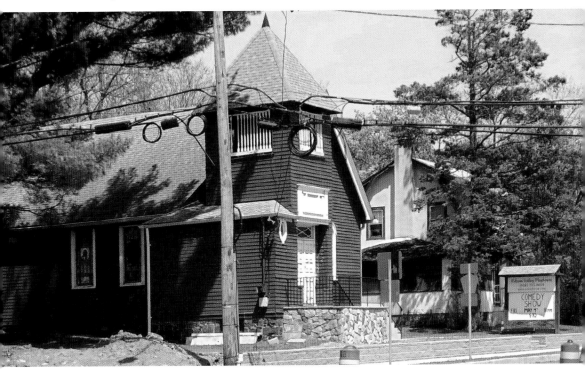

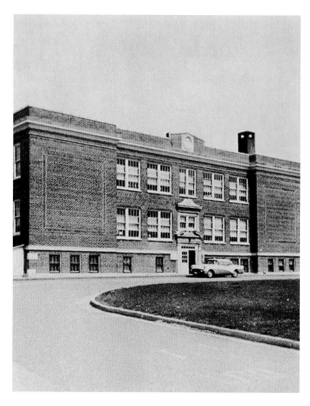

OAK TREE SCHOOL: The school was constructed in 1909 on Oak Tree Road, and a significant addition and remodeling took place in 1951. The image here dates from the mid-1950s, shortly after the addition. Dwindling attendance in the 1970s and 1980s forced the closure of several Edison schools. The building is currently occupied by a unit of JFK Hartwyck Medical Center, which offers residential care for long-term patients.

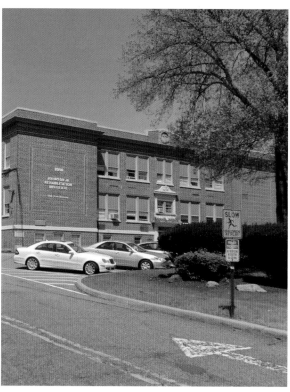

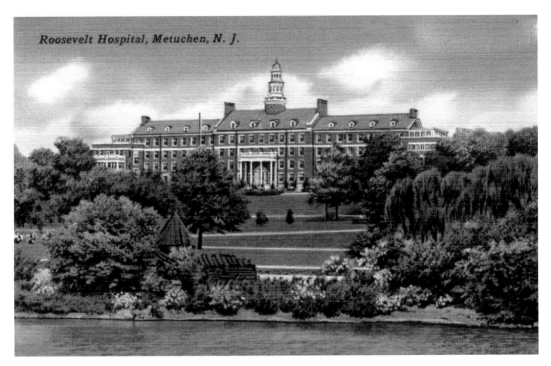

Roosevelt Hospital, Metuchen, N. J.

ROOSEVELT HOSPITAL: This Edison landmark (pictured on a 1940s postcard) was constructed in 1935-7 as a tuberculosis treatment center on an isolated parcel of county land. With the introduction of the Streptomycin antibiotic in 1946, the facility was no longer needed as a TB treatment center. The sanatorium was converted into a geriatric care facility, while portions were used for psychiatric patients. In 2012, the hospital was closed. From 2015-8 the building was converted into senior housing, with residents taking occupancy in 2018.

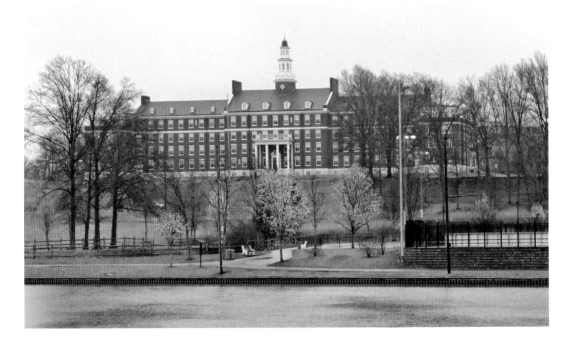

ROOSEVELT PARK ADMINISTRATION OFFICE: Middlesex County purchased 208 acres of land in Raritan Township in 1917 with the intention of building a tuberculosis hospital. Funding was short, and the land sat vacant until Franklin Roosevelt's New Deal programs brought the necessary funds and manpower needed to utilize the land. In 1933, Roosevelt Park was opened, about the time this photo of the administration office was taken. As outlined on the previous page, the tuberculosis hospital was constructed on a 13-acre section of the tract separated by a lake, commencing in 1935.

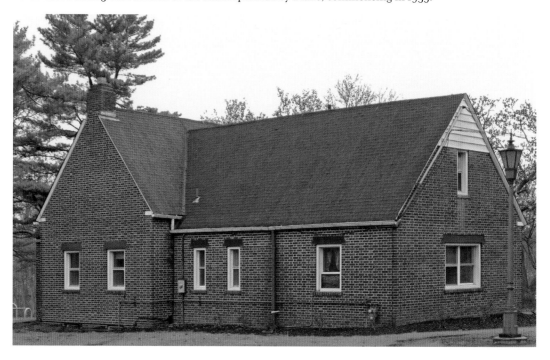

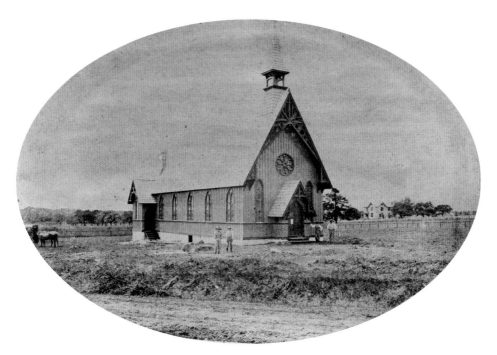

SAINT LUKE'S EPISCOPAL CHURCH: The Metuchen congregation was incorporated in 1866, and this church was constructed in 1868. This early photo dates from 1869. The Gothic Revival building has had very little alteration over the past century and a half. Alfred Joyce Kilmer, pioneer early Johnson & Johnson scientist (the man who developed baby powder) was married here in 1908. Kilmer, also a well-known writer and poet, was killed in World War One.

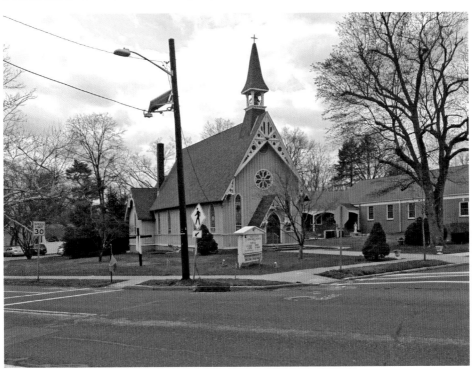

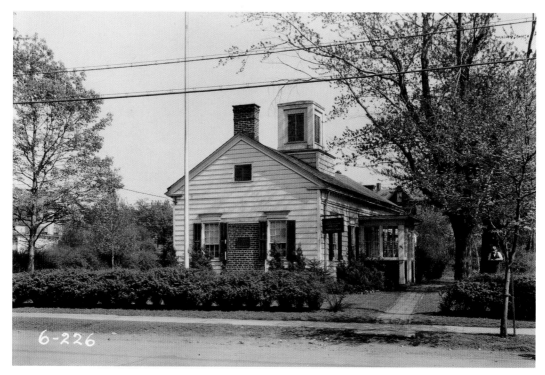

OLD FRANKLIN SCHOOLHOUSE: Originally a one-room building, the venerable schoolhouse was constructed in 1807 on what is now Middlesex Avenue in Metuchen. Public funds were raised in 1842 for an addition and repairs. During this renovation, they moved the building 45 degrees counter-clockwise to face west, where it currently sits (pictured in 1936). In 1873, another school was built nearby and this edifice was then utilized as a private residence until 1906, when it was purchased by the Borough Improvement League of Metuchen, who have restored and maintained the building while using it as their base of operations.

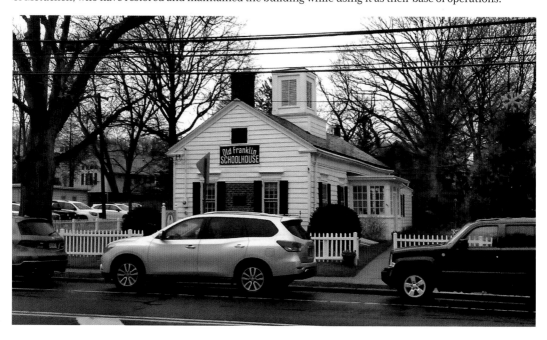

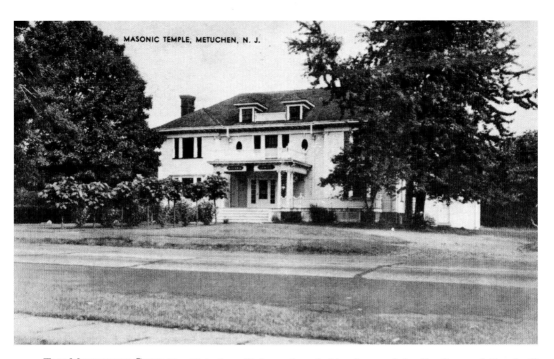

MASONIC TEMPLE, METUCHEN, N. J.

THE METUCHEN CLUB: The Metuchen Club was founded in 1890, and shortly afterward, they built this large clubhouse on Middlesex Avenue next to the old Franklin schoolhouse. The venue was the social hub of Metuchen, hosting parties, dances, and festivals. In 1927, the Mount Zion Masonic Lodge purchased the building, and they continue to meet there. The building, pictured on a 1940s postcard, is currently owned by the YMCA, who utilize the structure as their corporate office.

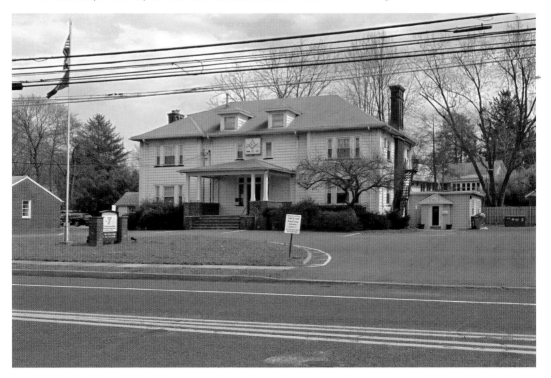

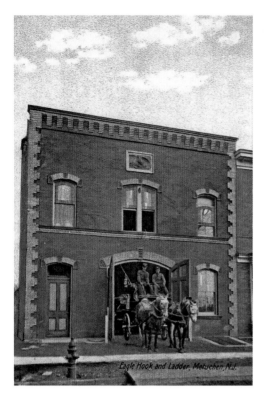

Eagle Hook and Ladder, Metuchen, N.J.

THE EAGLE HOOK AND LADDER COMPANY:
The company was founded in 1880. In 1888,
they constructed this distinctive building on
Main Street in Metuchen, pictured on an early
twentieth-century postcard. Originally, there
was a tall fire tower at the rear of the building.
In 1927, the borough consolidated all of the
independent firefighting organizations within
its confines into the Metuchen Fire Department.
Eventually, the space became impractical as
larger modern firefighting equipment could
no longer be housed there. The borough sold
the building in 1950 and it has since served in a
variety of different commercial uses.

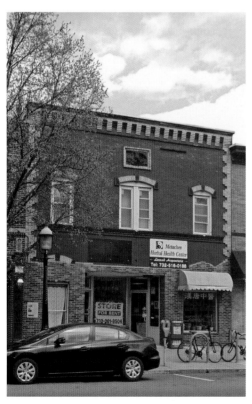

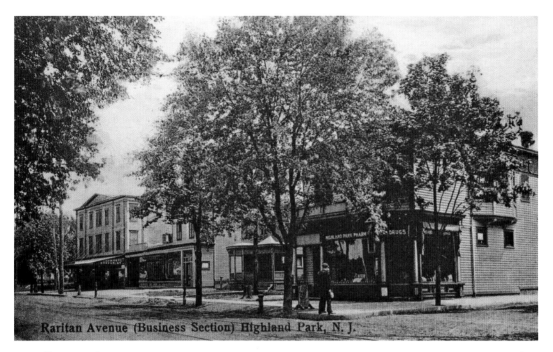

Raritan Avenue (Business Section) Highland Park, N. J.

RARITAN AVENUE: The borough of Highland Park seceded from Raritan Township in 1905. Situated on a bluff above the Raritan River, the hamlet sprang up during the nineteenth century around the several incarnations of the Albany Street Bridge (Route 27) leading to/from New Brunswick. Pictured c. 1910 is the commercial block in its infancy, one of the rare instances where the trees overwhelm the scene more so in the historic than in the modern view in this volume. Most of the structures survive, albeit with varying levels of alterations.

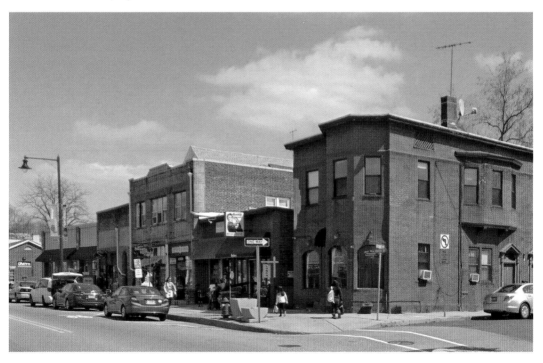

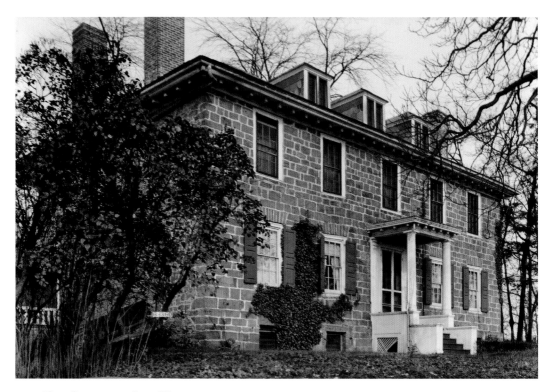

THE CORNELIUS LOW HOUSE: Cornelius Low was a successful merchant, and an early settler of Raritan Landing, which was a community along River Road in Piscataway. When his home was destroyed in a flood in 1738, Low purchased property on a high bluff and constructed this new house in 1741. One of the stateliest homes in the area in its time, the structure was always occupied by affluent, preservation-minded families, thus the building (pictured in 1936) remains in splendid condition. Middlesex County purchased the property in 1979, and converted it into a museum. In the 1990s, extensive restoration and preservation efforts were undertaken at the site.

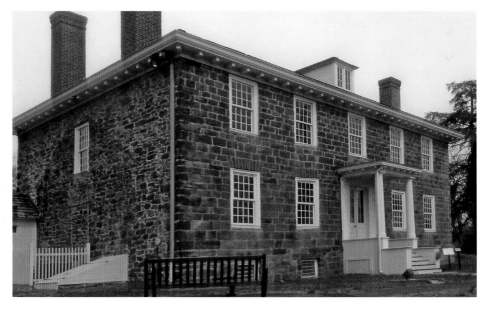

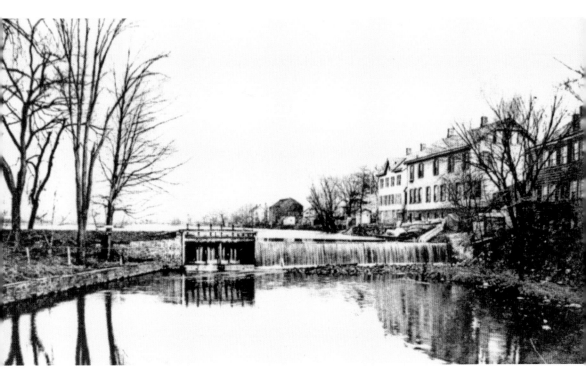

NEW MARKET POND DAM: There has long been a dam on Bound Brook in the New Market section of Piscataway. It was originally built in the eighteenth century to provide greater current for mills which sprang up on Bound Brook. The dam has been enlarged and altered a number of times over the past few centuries. Even though there are no longer any milling operations in the vicinity, there is a small park circling the pond where one can relax and enjoy a quiet moment.

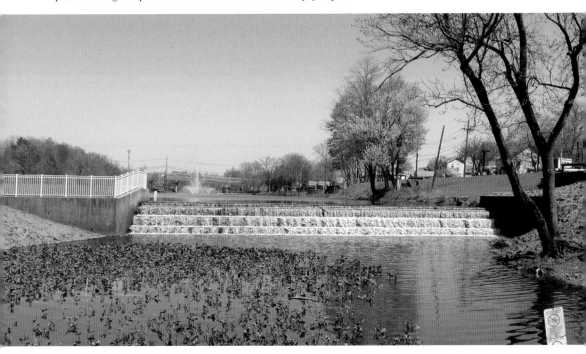

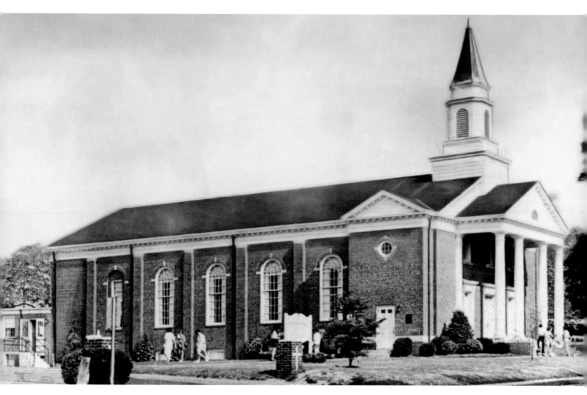

THE FIRST BAPTIST CHURCH OF NEW MARKET: The congregation was organized in the 1850s. In 1953, the original church burned to the ground. A year later, work was completed on the current building, pictured shortly after completion. Few changes have been made in more than six decades to the New Market Road edifice.

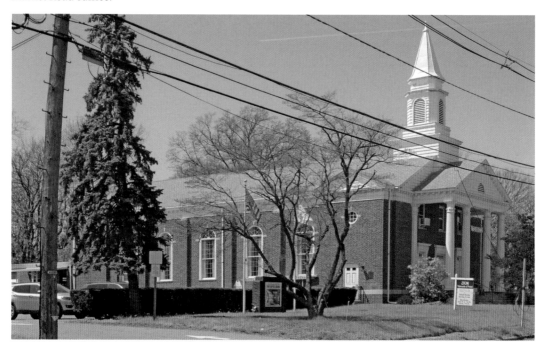

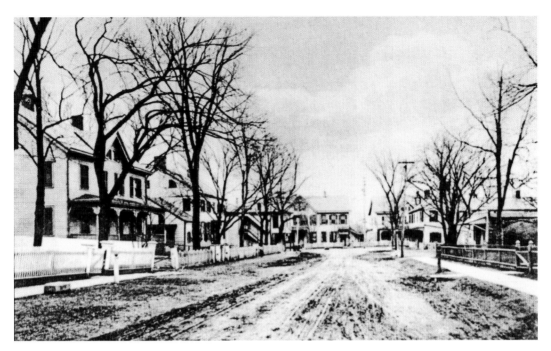

STELTON ROAD: The heart of the New Market section of Piscataway is pictured on a *c.* 1905 postcard. The buildings pictured on the western side (left of photograph) of Stelton Road remain with little alteration. The two Lakeview Avenue buildings in the foreground on New Market Pond were both demolished in the 2000s: the one on the right in 2004, and the one on the left in 2009. The land was incorporated into Columbus Park, which borders the pond.

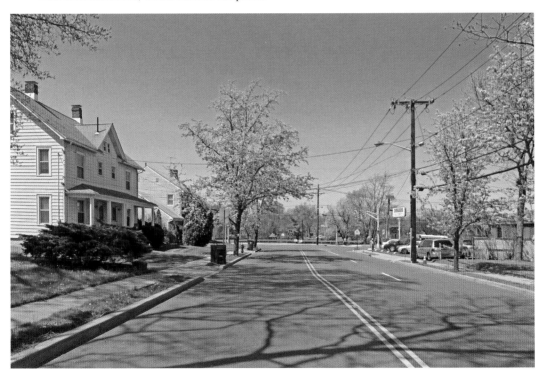

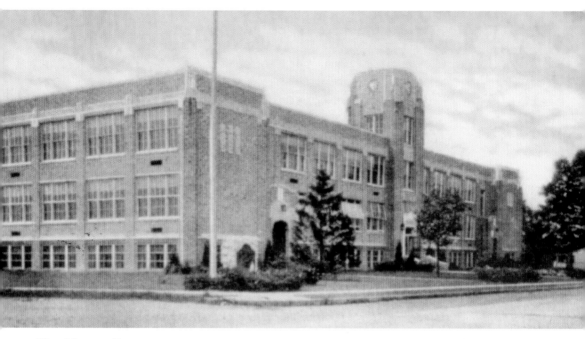

NEW MARKET SCHOOL: The long-time educational location for the New Market community's youth is pictured in the 1940s. The 1930 building was the third and final school building on the site, and the only building not to be destroyed by fire. Two previous schools, one built out of wood in the late nineteenth century, burned to the ground in 1903; the replacement building, which was constructed from brick, was gutted by a 1929 inferno. Dwindling enrollment forced the school's closure in 1979. It has since been converted into a postal facility and office space.

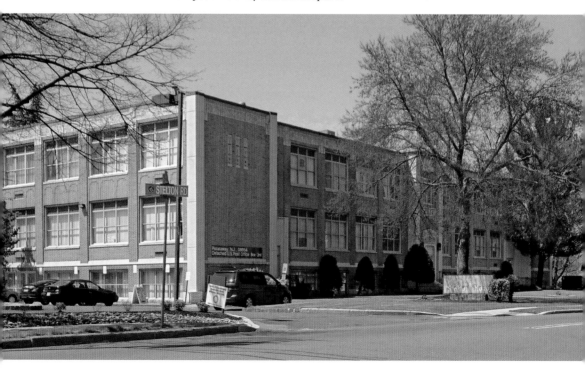

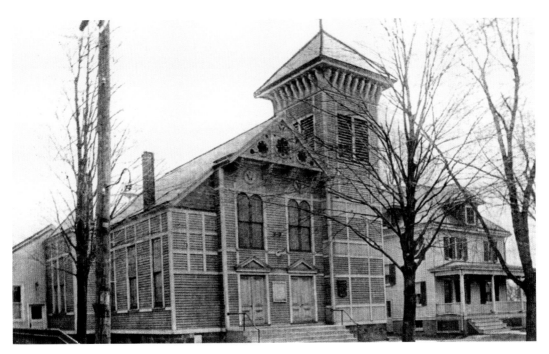

SOUTH PLAINFIELD BAPTIST CHURCH: The congregation dates to the late eighteenth century. Before erecting this building in 1880 (pictured in the 1920s), they went through two successive church buildings in the old Samptown section of town, located on the grounds of what is now Hillside Cemetery on New Market Road. In 1900, the original Grant School was constructed next door to the church, and since 1964 the neighboring school building has housed Keystone Community Living, an organization which assists people with developmental disabilities.

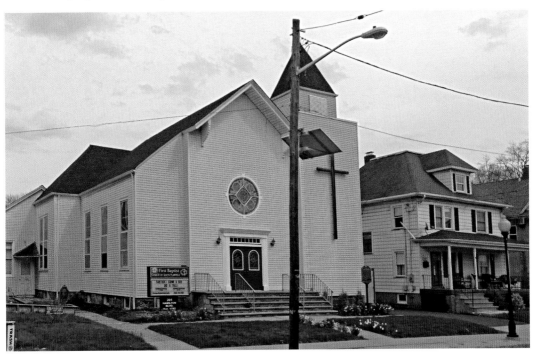

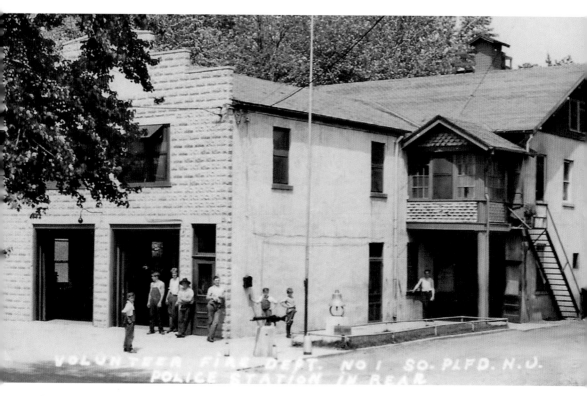

South Plainfield Municipal Hall: Pictured on a 1930s postcard is the long-time location of the town hall on Hamilton Boulevard. Originally constructed in the late nineteenth century and expanded on several times, the complex housed the borough offices, firehouse, and police department. The town built a new municipal building in 1961, and a new firehouse in 1967, at which point this structure was rented as commercial space. After housing many different ventures, the building is vacant as of 2018.

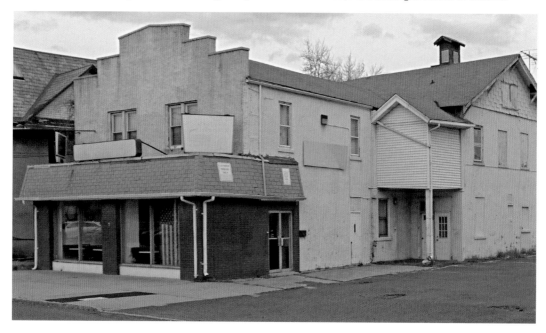

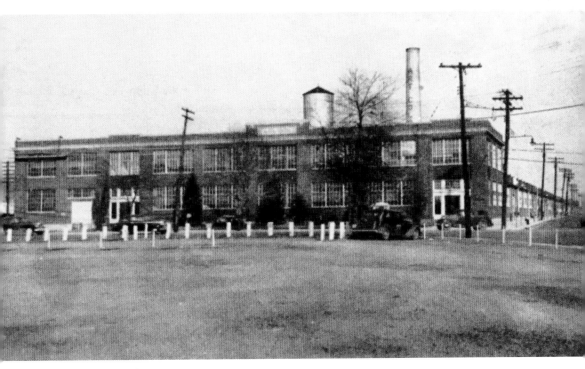

THE ART COLOR PRINTING COMPANY: Constructed in 1925, the factory was the industrial heart of Dunellen for nearly half a century. A magazine and pulp fiction publisher, the company was founded in New York City in the late 1800s and moved to Dunellen after constructing this plant (pictured in the 1930s). The firm handled the publication of *True Romance, Modern Screen, True Detective Mysteries,* and *Modern Romances* amongst many others. The plant closed its doors in 1968, leaving a serious impact on the borough. The property has been long been earmarked for residential and commercial redevelopment, which will likely begin in late 2018.

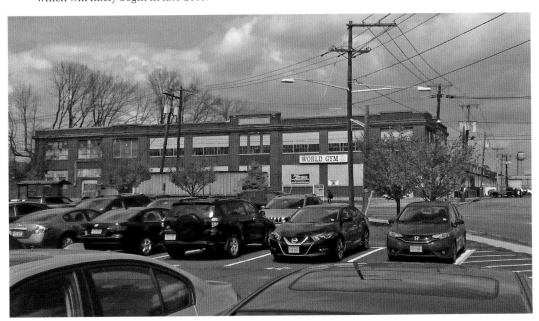

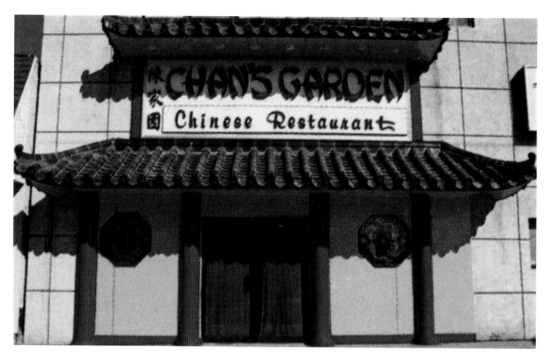

CHAN'S GARDEN: This Chinese restaurant across the street from Dunellen's North Street town hall was one of the most popular Asian restaurants in Middlesex county for many years. Hai Kan Chan opened the establishment in the late 1950s (pictured here shortly thereafter). Noted for their soups and sweet boneless spareribs, the eatery was profiled by the *New York Times* in 1981. A second location was opened in Livingston. Chan retired and closed the restaurant in the late 1990s. Chinese-American ping-pong champion Lily Yip opened a distinguished Table Tennis Center at this location shortly afterward.

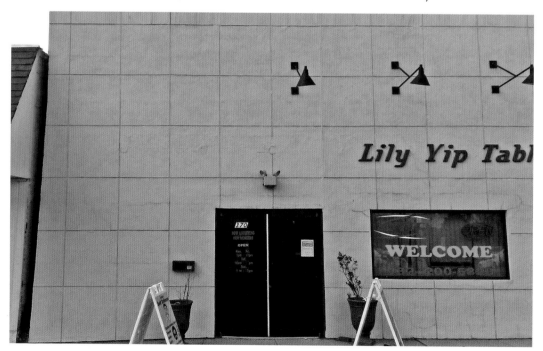

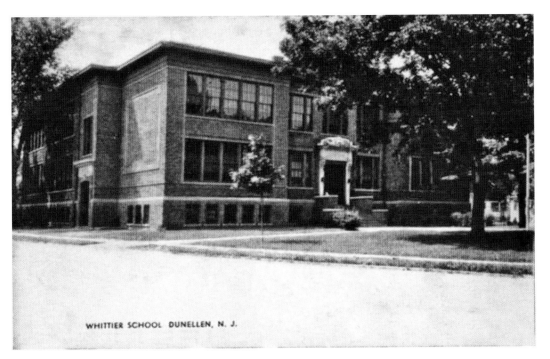

WHITTIER SCHOOL DUNELLEN, N. J.

WHITTIER SCHOOL: A school was first built at this location in Dunellen in the mid-eighteenth century. The school was rebuilt in the 1830s. The original structure was relocated to the rear of the school property in 1875 when the current building was erected. Additions and renovations were made in 1901, 1909, and 1920. The public schools in Dunellen were consolidated in the 1990s and the school was then used as a parochial school for a number of years. Pictured on a 1940s postcard, it is currently home to the Community Bible Church.

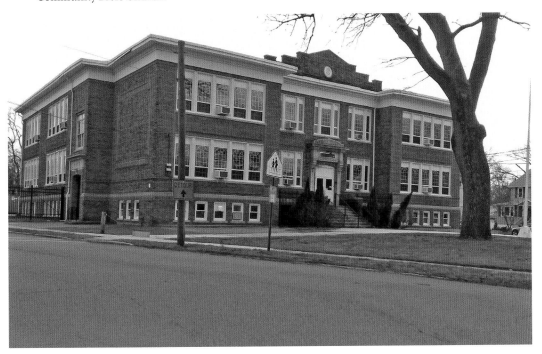

UNITED METHODIST CHURCH OF DUNELLEN: Pictured in the 1930s, the church got its start in the 1850s in the New Market section of Piscataway. They constructed this building at the intersection of Dunellen and Jackson Avenues in 1876. The church, the first in what is now Dunellen, predates the borough's secession from Piscataway by ten years. A religious school was constructed adjacent to the church in 1932. Other than a redesigned steeple, the church remains remarkably intact.

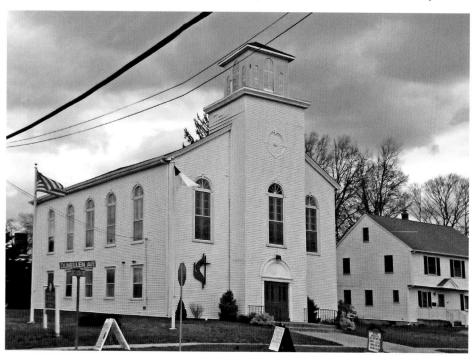

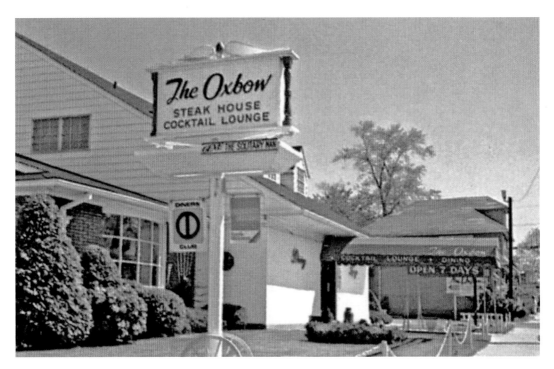

THE OXBOW STEAK HOUSE: What better way to end a volume on Middlesex County than to find ourselves at a fine Italian steakhouse in Middlesex borough? The Bambo family built the steakhouse in the mid-1960s, and it is pictured shortly after construction. The Qiko family purchased the business in 1976, and renamed it Carpaccio Ristorante in the late 1980s. Carpaccio is a type of appetizer made from thinly sliced raw meat or fish which was first served in the 1950s at the famous restaurant Harry's Bar in Venice.

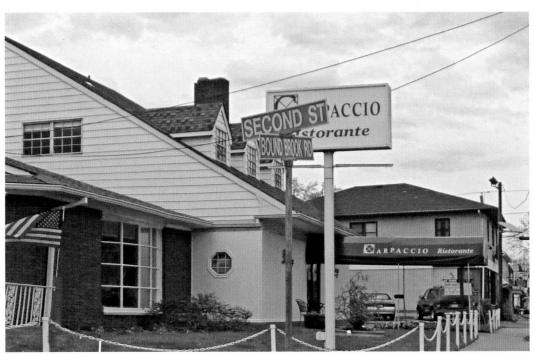

CREDITS AND ACKNOWLEDGMENTS

When publisher Alan Sutton emailed me early in 2018 asking what my next book would be, I was lost in the daily grind. While I wasn't actually thinking of working on any project, his email ignited a spark in my brain and over the next few weeks I started sketching out *Middlesex County Through Time*. My last volume, *Ocean County Through Time*, was inspired by my mother's connection to that place. This work was definitely done with my father in mind. Dad grew up in South Plainfield, where he lived until he graduated high school, and by way of the United States Air Force went off to fight in Vietnam. This tome owes an even larger debt to my father, a retired IT professional, who was there to rescue me and help recover all of my data after I fried my ancient laptop during the late stages of completion. Lesson learned. Back up your work on a flash drive, folks!

I can't give enough praise for the service performed by our federal government for not only archiving their unsurpassed image collection at outstandingly high quality but allowing the public easy and free access to its many treasures. The Library of Congress was the source for the vintage front cover image and the pictures on pages: 5, 6, 7, 9, 11, 13, 44, 45, 74, 79, and 80. The picture on page 71 is courtesy of the United States Department of the Interior, National Park Service, Thomas Edison National Historical Park. I am especially indebted to Leonard DeGraaf, Edison archivist, for his quick attention and helpfulness. Also, courtesy of the National Park Service via the National Register of Historic Places Database are the vintage images on pages 35, 36, and 48. Many thanks to River Ridge Terrace in Highland Park for the rooftop access for the modern front cover shot, especially Suzanne and Pedro. The Old Bridge Police Department, the Cornelius Low House, East Jersey Old Town Village, Rutgers University, Weird NJ, Glenn Vogel, the NC crew: Scotty, Dougie Fresh, Bass Marc, Mike C, Hamilton, Johnny Rock, and Ricky D. Thank you all.

And most importantly I want to thank my family: Claire, Leyna, Rossy, Albert the bird, Mom and Dad, Michael, and Tommy. Thanks to all the cousins, in-laws, nephews and nieces, and anybody I have accidentally omitted. God Bless everybody in the great Garden State.